Connecticut
Pirates
&Privateers

Connecticut Pirates & Privateers

Treasure and Treachery in the Constitution State

WICK GRISWOLD

THE
History
PRESS

Published by The History Press
Charleston, SC 29403
www.historypress.net

Copyright © 2015 by Wick Griswold
All rights reserved

First published 2015

Manufactured in the United States

ISBN 978.1.62619.921.7

Library of Congress Control Number: 2015942733

Notice: The information in this book is true and complete to the best of our knowledge. It is offered without guarantee on the part of the author or The History Press. The author and The History Press disclaim all liability in connection with the use of this book.

Contents

Contents

Acknowledgements

As always, I must express heartfelt thanks to the miraculous team that makes our books possible, so here goes: Suki Schavoir, for your imaging magic, warm wishes and cheery e-mails. Frederick Schavoir, Griswold Point's artist in residence, for your maritime Impressionism and dart matches. Carla Griswold Giorgio, Ray Guasp, Jeff Feldmann, Troy Funk and Scott Larkham, for your fabulous photographs. My Evil Twin, Woody Doane; David Goldenberg; and Bonny Taylor, for the institutional support of Hillyer College. The ace team from the Connecticut River Museum—Amy Trout, Bill Yule, Jennifer Dobbs-White and Chris Dobbs—for all the lore and legends. Louisa Alger Watrous and Maribeth Bielinski down at Mystic Seaport. Tabitha Dulla at The History Press, for her wisdom and support. Catalyst and Muse Jacqueline Talbot. And, of course, Annie and Maggie, for all the love, laughs and lunches.

Introduction
The Piratical Imagination

You can stand on the narrow strip of sand at the point where the Connecticut River meets Long Island Sound and enjoy a reverie. The sun dancing over the waves can skip your imagination across centuries of the memories of ships and people who have sailed on these historic waters. The vast majority of these brave mariners were good, mostly honest seafarers. Fishermen, merchantmen, immigrants, bargemen and tankermen have plied these waters for centuries. Warships and Coast Guard vessels have sailed by on their way to save lives or fight heroic battles. Today, replicas of famous sailing vessels like Henry Hudson's *Half-Moon* and the slave ship *Amistad* regularly sail past this spit of land. It is a great place to contemplate the role that ships and the people who sailed them play in the creation of the ongoing narrative that becomes, and is, Connecticut's history.

Across the Sound lies Gardiners Island, named for Lion Gardiner, the military engineer who built a fort at the mouth of the river that allowed the English to settle the area in safety. Relatively short voyages to the east bring you to the historic ports of New London, Newport, Providence and Boston. To the west, New Haven and New York are within easy sailing distance. The confluence of Long Island Sound and the Connecticut River is ideally located to serve as an axis of maritime travel between the major ports of the eastern seaboard and beyond. As early as the seventeenth century, ships built for the Connecticut River were sailing down the coast to trade with nascent colonial southern cities and the rum- and molasses-rich Caribbean islands. The Caribbean, thanks to modern popular culture, has strong associations

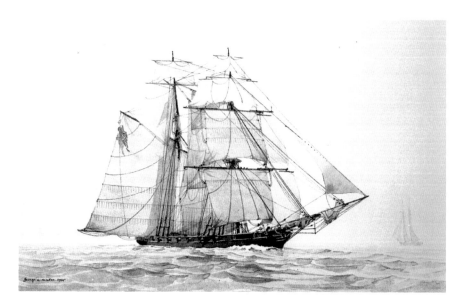

The privateer *Prince de Neufchatel* is a good example of the ships that once plied these waters. ©*Mystic Seaport.*

in our collective consciousness that focus on some of the most romantic and enigmatic seamen of all time: pirates.

The very name conjures deeds of derring-do, skull and crossbones flags, terror-stricken maidens and overflowing treasure chests. We can imagine rakishly dressed buccaneers brandishing cutlasses and flintlock pistols in pursuit of riches, glory, freedom and fame. Our collective memories are full of sleek corsairs silhouetted against the moon, sailing the Seven Seas in search of gold, silver and jewels. Many of these fabled buccaneers plied the waters off the coast of Connecticut. Some of the most famous pirates in history—Captain William Kidd, Blackbeard and David Marteens—are all purported to have buried vast treasures of almost unimaginable value on the shores of what has become known as the Nutmeg State. To this day, treasure seekers sweep their metal detectors and laser imaging devices over the state's riverbanks and islands in the hopes of unearthing unfathomable riches.

As we shall see, Connecticut nurtured a few homegrown scalawags of its own, but its major spawn of sea raiders took the form of privateers, a type of pirate who had been legitimized by government to pillage legally. The state's key role in America's colonial development, its engagement in early maritime commerce and its often contentious relationships with Great Britain and the Royal Navy led it to become an incubator for privateers, smugglers and other not-so-legal seafarers. The colony of Connecticut and its seacoast and

river towns were sending pirates to plunder Native American shipping and settlements as soon as Europeans arrived in the area. Its privateers began to prey on Dutch, French and, later, British trading and military vessels in the early seventeenth century.

As our inquiry into this history unfolds, we will take a closer look at the often blurry lines between what constitutes a pirate and a privateer. They are terms that are sometimes used interchangeably, but they have fine shades of meaning and legal status that often meant the difference between an ignominious death on the gallows or a comfortable retirement with plenty of silks, pelf and rum. Just to confuse matters a bit, many of the seafarers who followed the corsair's career path were a little bit of both, as well as being legitimate traders at the same time. The term *privateers* is often used to describe those whose activities were sometimes, but not always, sanctioned by letters of marque. Often a legitimately sanctioned privateer might take a vessel that belonged to a country that was not considered an enemy or that sailed under the same national flag.

Letters of marque were documents that governments (national, colonial, state and local) issued that supposedly made it legal for the sailors who had them to attack and capture "enemy" shipping. There was a great deal of latitude in terms of to whom and how they could be issued and interpreted. Between the seventeenth and nineteenth centuries, well over two hundred Connecticut ships sailed as certified privateers and captured hundreds of ships and millions of dollars in cargo. Not only were letters of marque issued with stringent rules to delineate a privateer's legal behavior, but the owners of the privateering vessel were also required to post a cash bond to ensure that their captains followed the parameters set by those rules.

Privateers played extremely critical roles in the defeat of the British during the Revolutionary War, and although they did not fare quite so well in the War of 1812, they also were instrumental in the young republic's victory. As we shall see, during that war, more than two dozen Connecticut privateers' ships were burned while they lay at anchor or were on the ways in Essex when the Royal Navy attacked them. It was one of the costliest raids ever suffered by a town in the United States. More ships were destroyed than were lost at Pearl Harbor. Connecticut's strategic location, business climate and shipbuilding industry made it a haven for privateers and the merchants who profited from their spoils.

Our musings, tempered with historical fact, lore and legends, will take us from the gold-laden galleons of the Spanish Main to the gallows on London Dock, where Captain Kidd, who sailed along the Connecticut coast, met

To Captain commander of the private armed

called the

INSTRUCTIONS

FOR THE PRIVATE ARMED VESSELS OF THE UNITED STATES.

1. THE tenor of your commission under the act of Congress, entitled " An act concerning letters of marque, prizes, and prize goods," a copy of which is hereto annexed, will be kept constantly in your view. The high seas, referred to in your commission, you will understand, generally, to extend to low water mark; but with the exception of the space within one league, or three miles, from the shore of countries at peace both with Great Britain and with the United States. You may nevertheless execute your commission within that distance of the shore of a nation at war with Great Britain, and even on the waters within the jurisdiction of such nation, if permitted so to do.

2. You are to pay the strictest regard to the rights of neutral powers, and the usages of civilized nations; and in all your proceedings towards neutral vessels, you are to give them as little molestation or interruption as will consist with the right of ascertaining their neutral character, and of detaining and bringing them in for regular adjudication, in the proper cases. You are particularly to avoid even the appearance of using force or seduction, with a view to deprive such vessels of their crews, or of their passengers, other than persons in the military service of the enemy.

3. Towards enemy vessels and their crews, you are to proceed, in exercising the rights of war, with all the justice and humanity which characterize the nation of which you are members.

4. The master and one or more of the principal persons belonging to captured vessels, are to be sent, as soon after the capture as may be, to the judge or judges of the proper court in the United States, to be examined upon oath, touching the interest or property of the captured vessel and her lading: and at the same time are to be delivered to the judge or judges, all passes, charter parties, bills of lading, invoices, letters and other documents and writings found on board; the said papers to be proved by the affidavit of the commander of the capturing vessel, or some other person present at the capture, to be produced as they were received, without fraud, addition, subduction or embezzlement.

By command of the President of the U. States of America

Jas Monroe *Secretary of State.*

During the War of 1812, letters of marque were issued at the federal level. This one is signed by Secretary of State James Monroe, as proxy for President James Madison. ©*Mystic Seaport.*

his grisly (and, many claim, undeserved) end. We will harken to the tale of Blackbeard skulking ashore at New London to march his crew inland with the intention of burying a vast fortune that may or may not have been discovered and unearthed in the twentieth century. We will trace the careers of some of the great Connecticut privateer captains, following their tales of glory, profit, adventure and sometimes imprisonment.

The history of pirating and privateering in Connecticut is an integral and important part of America's maritime heritage. The stories that we shall examine return us to the bygone days of seagoing adventure under sail. Those days still resonate with children (and adults) when buccaneers and their swashbuckling adventures come to mind. (*Swash* was an old term for hitting something hard, and a buckler was a shield. Most pirates and privateers disdained shields, but they could hit hard and often.) Let's let our imaginations stand on the beach where the Connecticut River meets Long Island Sound and travel back a few centuries to take a closer look at some of the seafarers who made early Connecticut a port of call for pirates, privateers and other like-minded freebooters.

Part I
Pirates

DAVID MARTEENS

One of the most fascinating and mysterious chapters in Connecticut pirate lore concerns the whereabouts of a fantastically rich treasure that was taken from a Spanish galleon in the middle of the seventeenth century by the Dutch/English pirate/privateer known as David Marteens (or Martins). Although he was Dutch by birth, he often sailed and marauded in the company of English pirates. He was often granted letters of marque by the governors of the English-held Caribbean islands. His primary base of operations was the island of Tortuga off the coast of Venezuela, but he ranged far and wide in the Caribbean and around Central and South America. At one point, he joined forces in common cause with the notorious freebooter/politician Sir Henry Morgan and the pirate captains Jackman and Freeman Morris, sailing under letters of marque granted them by the rapacious governor of Jamaica, Thomas Modyford.

These doughty buccaneers and their polyglot, bloodthirsty crews sailed to Mexico with a plan to plunder. The sailors and their officers marched several miles inland through dense, disease-spawning jungle and took the capital of Tabasco Province by surprise. The pirates/privateers looted and pillaged to their hearts' content, making off with gold, jewels and weaponry that the residents hadn't had time to hide due to the swiftness of the attack. Their elation at the success of their raid was to be short-lived, however.

They loaded up their booty and slogged back through the jungle with thoughts of rum and ease as motivation. Much to their dismay and existential

The pirate David Marteens captured the *Neptune* galleon and plundered its gold, silver and jewels.

peril, however, their anticipated ease was not to be so easily accomplished. When they finally returned to their ships after their hot, insect-ridden march, there was a surprise in store for them. Their vessels were now securely controlled by the well-armed soldiers of the Spanish governor. The English privateers needed to improvise an escape plan, immediately.

The resourceful sailors captured and commandeered a fleet of some smaller vessels that could outsail the Spanish now in control of their former, larger ships. They set a course that took them to Honduras. There they regrouped, reloaded their weapons and perpetrated yet another astonishingly successful raid. They stole a ship and this time left it with sufficient guards to keep it secure and safe. Then they rowed and sailed their small boats almost one hundred miles upstream to the town of Granada. Another surprise attack again allowed them to pillage and plunder at will. The English marauders eventually made off with a very significant and lucrative haul of loot. The fortunate captains returned to the friendly ports of Jamaica and were hailed as heroes for the vexations and losses they inflicted on the hated Spanish.

After enjoying the pleasures that a pirate-friendly town could offer, the restless mariners were not content to rest on their laurels. Captain Marteens

used some of the proceeds from his raiding to procure another well-armed vessel and assembled a crew of battle-hardened corsairs, able-bodied seamen and wharf rats. Not long after his new ship put to sea, it was his extreme good fortune to discover, chase down and capture the Spanish galleon *Neptune*. The slow-sailing *Neptune* was making its stately paced way back to Spain heavily laden with an astounding treasure of gold, silver and jewels estimated to be worth at least $20 million in 1655 dollars (the equivalent of at least $300 million in today's currency). In an uncharacteristically gruesome turn of events, Marteens and his men promptly executed the officers and crew of the opulent Spanish galleon. They took their time offloading the treasure onto their pirate ship and made sail for their home base on Tortuga to plot their next move.

While sailing back to its homeport, Marteens's vessel, loaded with loot, was accosted by another ship. He presumed that it was captained by a fellow pirate who had somehow learned about his newly acquired ill-gotten gains and was anxious to relieve him of the same. The stranger fired several cannonades at the fleeing buccaneer, but Marteens was able to successfully outrun him with the help of a fair breeze. The pirate and his crew put into the friendly island of Tortuga in a state of high paranoia and anxiety. He commanded his crew to bury the booty in classic pirate fashion on their home turf. Satisfied that it was well secreted, he put back to sea in search of more wealth.

Yet the swashbuckling captain's mind could never completely rest easy; he was convinced that his treasure was not secure. Marteens began to obsess more and more about the ship that had chased him to Tortuga. He became convinced that its captain was at that very moment digging up his hard-won pelf. He ordered his ship about and sailed with all due haste back to his nest. Much to his relief and delight, the wooden crates of precious metals and jewels were exactly where he had interred them. In order to gain some peace of mind, the captain decided to find another, less obvious spot to stash his cache of treasure.

He loaded the goods back aboard his ship and undertook a meandering voyage up the eastern seaboard of what were beginning to be known as the American colonies. His band of buccaneers captured a few small prize vessels as they went and raided a couple of small towns, but their main mission was to find a safe place to hide the glittering Spanish lucre. They were caught in some very tempestuous weather, most likely a hurricane, off what is now the New Jersey coast. The battered ship and crew were relieved and thankful to finally reach the relatively calm waters of Long Island Sound. There they

could begin to make some much-needed repairs to their rigging and relax a bit after being buffeted about by the extraordinary weather conditions.

While exploring the Sound, Marteens poked his bow into the estuary of the Connecticut River. The wind being mostly favorable, he made his way all the way upstream to the town of Windsor. The oldest town in Connecticut, Windsor was still a relatively small settlement in the 1650s. Its thoroughly English residents were guarded and wary after years of dicey relationships with the Dutch. Still not totally at peace with all the indigenous people of the area, they were a bit disconcerted to have a pirate crew land in their midst as well. Marteens's men pitched a makeshift camp, but a cadre of heavily armed villagers maintained a vigil, monitoring their movements from a discreet distance. Realizing that they were under scrutiny and probably outgunned, the pirates, under cover of darkness, carried their crates of treasure deep into the woods and buried them for the second time. Shortly thereafter, they sailed down the river to continue their freebooting ways.

After two years of somewhat successful plunder and pillage, Marteens once again began to fall prey to the gnawing uncertainty regarding the security of his treasure. He sailed back up the Connecticut River and made landfall at Windsor. The town's residents almost immediately were put on high alert and armed themselves against what they feared could be a possible invasion. Marteens, realizing that his men might get the worst of it if it came to a fight, requested a parlay and asked if his crew could camp for a few weeks under a flag of truce. He promised that they would then leave Windsor, never to darken its town green again. The townsfolk were somewhat skeptical, but they knew they had superior firepower so they agreed to the arrangement. The fact that Marteens spread some gold and silver throughout the local economy probably helped his cause, as well.

Under his strict orders and watchful eye, his crew dug up the treasure once again and quietly carried it deeper still into the woods until they came upon a site whose description leads historians to believe that it was located on the East Branch of Salmon Brook, not far from its conjunction with the West Branch. Ironically, this spot is close to the present site of Old Newgate Prison, where more than one colonial pirate was incarcerated under harsh conditions. The bullion, coins and gemstones were interred once again, but this time they were buried for good. The pirates sailed away downstream to plunder on and never entered Connecticut waters again.

Over the years, the *Neptune* treasure has spawned sporadic searches by a variety of treasure hunters. One of the most interesting was instigated in the 1920s by a quixotic man named Nelson. He came across some obscure

references to the treasure buried by Marteens while doing research in a Boston library. When his schedule permitted, he would traipse about the banks of the Salmon Brook in the hopes of finding some sign or marker that might indicate where the treasure was buried. His interest was really piqued when he discovered a series of rocks into which were carved arcane symbols, letters and numbers. Convinced that he was hot on the trail, he enlisted the aid of a buddy of his named Ruches and entrusted him with his arcane knowledge and theories.

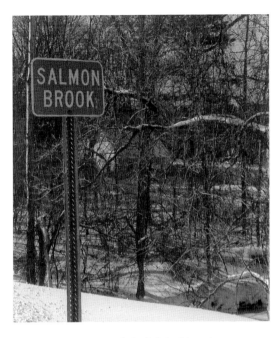

David Marteens reputedly buried the *Neptune*'s treasure on the banks of Salmon Brook. *Photo by Troy Funk.*

The indefatigable pair spent several more years poking and digging around the area and found even more stones with odd inscriptions. Then they made the error that spelled the end to their enterprise. The two men dug up the inscribed stones and dragged them back to Ruches's house so they could be perused and deciphered in a leisurely fashion over a glass or two of beer. Nelson slipped into his restless dotage and passed on to the realm of pirate ghosts without realizing his dream of riches. Ruches, now the sole proprietor of the numinous stones, sent them off to a prominent university archaeologist to get a professional opinion as to their provenance. The scholar agreed that they truly did allude to the location of a buried treasure. But he determined that unless they were in their original locations, they would be of no value in determining where the loot lay.

Further research by the archaeologist somehow determined that the stones were carved by someone named Robert Caldwell. Still more research on his part revealed that the stone-scribing Caldwell was a member in good standing of the pirate crew of Captain David Marteens. Whether anyone before or since Ruches ever came upon the treasure may never be known. No one has ever owned up to it. Treasure seekers still stalk Salmon Brook

in the hopes of a profitable *ping* from their metal detectors. It is enticing to think that a vast fortune still lies buried in East Granby, Connecticut, or thereabouts, waiting for someone in the twenty-first century to restore it to the light.

CAPTAIN KIDD

No other pirate's name resonates throughout buccaneering history with more myth, lore, legend and mystery than that of Captain William Kidd. There is an aura of corsair cachet like no other attached to this magical name. Captain Kidd is the archetypal buccaneer; the sagas of his seagoing exploits, political intrigues and unfortunate demise combine to create echoes and ripples of romance that glorify the piratical age. Over time, he has come to exemplify the exploits of the dashing, larcenous and sometimes homicidal bands of sea rovers that still sail through our collective reveries of long-lost ages and adventures. His voyages propelled him across large swaths of the globe. He became caught up in webs of political and economic chicanery far beyond his ability to understand a rapidly changing world. But today, more than two centuries after he sailed, much of his ongoing legend is still alive and well in Connecticut. Along the shores of Long Island Sound and the banks of the beautiful Connecticut River, Captain Kidd's name can still cause a heart to flutter in excitement and an imagination to conjure a chest full of treasure.

William (he is sometimes incorrectly called Robert) Kidd was a Scotsman, born in the middle of the seventeenth century. His father was either a sea captain or a minister, or both. In either case, his son, William, was orphaned at an early age and made his way across the Atlantic to the fledgling colony of New York. Young William soon signed on aboard a colonial privateer that was commissioned to protect English interests in the Caribbean from the trepidations of the French and the Spanish. Demonstrating his executive ability early in life, Kidd led a successful mutiny against an incompetent captain. He and the crew members loyal to him seized the privateer and renamed it (not without irony) the *Blessed William.* Kidd was elected captain and quickly received a privateering commission from the governor of Nevis. Shortly after assuming this captaincy, he and the crew of the *Blessed William* attacked the French island of Mariegalanie. They sustained very few casualties and sacked and looted the port town in what turned out to be a very profitable piece of pillaging.

Captain William Kidd cuts an elegant figure in New York before sailing on his ill-fated adventure. *From almay.com.*

After his ship was stolen out from under him by the notorious pirate Robert Culliford, Kidd, with a tidy sum in his pocket, made his way to New York. There he had the good fortune to marry a very wealthy widow named Sarah Bradley Cox Oort, who would remain a faithful, supportive wife to him throughout his life. Personable, dashing and articulate, Kidd began to make a name for himself in the young city's social circles. He caught the attention of Lord Belomont, who was governor not only of New York but also much of New England. Belomont proposed that Kidd outfit a ship whose purpose would be to attack not only the ships of the French enemy but also English pirates such as Thomas Tew, Thomas Wake, William Maze and John Ireland. The extralegal maritime activities of these gentlemen of questionable virtue were cutting into the colony's (and Belomont's) revenue stream.

Kidd found himself beginning to be enmeshed in an increasingly complicated political and economic set of circumstances. He decided to accept Belomont's offer as a way of showing his support to the English Crown and to his influential friend, the governor of his newfound home. Kidd sailed for England, where he quickly became caught up in a heady social swirl. He accepted a privateering commission from a group of

titled aristocrats, including the king himself. Interestingly, the famed Earl of Oxford was among the sponsors of his privateering outfit. Kidd had embroiled himself in a miasma of intrigue, personalities, greed and history that would prove to be his ultimate undoing.

He spent his consortium of backers' money wisely, though. After combing the docks for likely vessels, Kidd purchased a ship called the *Adventure Galley*. Rated at 285 tons, it carried a formidable arsenal of thirty-five cannons and could accommodate a ship's company of 150 officers and crew. The singular feature that was to make the *Adventure Galley* so well suited to Kidd's piratical activities was the fact that it could be rowed as well as sailed. Adjacent to its gun ports were openings through which oars could be thrust to sweep the ship forward when there was no wind. This served to give it a tactical advantage when pursuing or being pursued by another vessel. It could get underway when other becalmed vessels could not.

After equipping the *Adventure Galley* for a long voyage and handpicking a cadre of officers and crew, Kidd slipped his moorings and proceeded down the Thames. His mind was full of dreams of prizes and fortune. He felt especially secure in the knowledge that his activities were sanctioned by the very highest political and economic powers of one of the world's greatest sea powers. This might have given Kidd a bit of inappropriate and ill-omened hubris. As he was making his way downstream, he passed a Royal Navy vessel anchored at Greenwich. Etiquette at the time demanded that Captain Kidd dip his flag and fire a cannon in a show of respect to flag and country. For some reason, Kidd ignored this obligation and sailed alongside the ship without acknowledging it. Enraged, the navy captain fired a cannon in order to force Kidd to acknowledge who was who in the grand scheme of things. Kidd's crew then did the unthinkable: those aloft and at the rail all turned their backsides to the warship, pulled down their pants and forcefully slapped their buttocks in an egregious display of disrespect unheard of in polite naval society.

The Royal Navy was quick to exact its revenge, however. Kidd's ship was weathered in at the mouth of the river and was forced to lie at anchor until conditions became more favorable. The *Adventure Galley* was then boarded by a press crew from a Royal Navy warship, and Kidd lost over half of his crew and officers before he even put to sea. His heartfelt protests fell on deaf, supercilious ears, and more than one navy officer performed his duty with a self-satisfied smirk, content with the knowledge that the affront to the admiralty's honor and prestige was more than adequately addressed.

Smarting from this insult (as he perceived it), Kidd sailed short-handed across the Atlantic to New York, where he hoped to replenish his depleted

ship's company and finish outfitting his corsair for a long voyage to the Red Sea and beyond. Unfortunately, New York's waterfront dives and boardinghouses did not have a surfeit of the top-quality sailors and officers that Kidd had hoped to hire. He was compelled to put together a ragtag crew of ruffians, greenhorns, wharf rats, criminals and, fortuitously for him, some battle-hardened pirates.

Kidd then sailed off to the Red Sea, where he would undergo an astounding series of misfortunes and misadventures that resulted in his untimely demise at the end of an admiralty rope. He was plagued by concatenations of poor decisions and just plain lousy luck. His spanking-new vessel proved leaky, crank and not always easy to maneuver. His crew was decimated by the curse of cholera, and many deserted the ship. Captain Kidd was under constant threat of mutiny from those who decided to stay aboard. The cruise became an unending cascade of calamity and catastrophes. From his privateer's (and soon-to-be pirate's) point of view, though, the worst part of the whole thing was that he wasn't able to capture any prizes. Since he and his men wouldn't get paid without prizes, and his investors would take a dim view of all their money draining away for nothing, Kidd became increasingly pressured to come up with some treasure.

Kidd's reluctance to attack any or all of the shipping that they happened upon increasingly caused resentment, distrust and anger among his crew. When Kidd refused to capture a Dutch merchantman because England was at peace with Holland at the time, a crewman named William Moore excoriated his captain in very harsh, unfavorable and direct terms. Kidd's response was to bash poor Moore's head to mush with an ironbound oaken bucket. His skull fractured, Moore barely clung to life overnight and died a painful death the following morning. Murdering crewmen was frowned upon, but Kidd believed that his sponsors and friends among the nobility would exonerate him because he was still acting in their best interests.

To further exacerbate his woes, Kidd found himself becalmed in the Indian Ocean in the middle of a fleet of Royal Naval warships. Both Kidd's and the navy's crews had been hard hit by scurvy, the curse of long-distance voyagers before the efficacy of anti-scorbutics was discovered. Kidd was rowed over to the flagship of the fleet to dine and parlay with its captain. In the course of their discussions, the naval officer demanded that Kidd give him thirty seamen to replace those who had died aboard the warship. Kidd reluctantly agreed, but he knew that losing thirty of his already depleted and mutinous crew would render him virtually unable to sail the *Adventure Galley*, much less capture any prize ships. So Kidd promised to send the sailors over

in the morning. Since there was no wind and the navy couldn't give chase, Kidd took advantage of the oar power his boat boasted and slunk cravenly away under the cover of darkness. Not pleased, the Royal Navy captain immediately branded him as a pirate, an ignominious title that would ever be associated with his name.

The irony, of course, was that as a pirate, Captain William Kidd was an abject failure up to that point. The hapless mariner had taken no prizes, made no money, burned through most of his supplies and resources and faced a surly, mutinous crew that was antsy, bored and hungry for a payday. Although the sailors who remained loyal to their captain appreciated the fact that he had saved them from service in the king's navy, they were increasingly aware that no prizes meant no pay. Both the crew's and Kidd's luck was about to change for the better in that regard, though.

On January 30, 1698, Kidd spied the huge Armenian-built ship the *Quedagh Merchant* flying the French flag. Since France was an acceptable enemy, and its ships were well within Kidd's privateering purview, he raised the French flag himself and quickly came alongside the much slower and less maneuverable commercial vessel. Once within cannon range, Kidd displayed his true colors and took the *Quedagh Merchant* as a prize. Its captain produced passes he had secured from the French East India Company. Kidd seized these as proof that his capture of the ship was legal and proper.

It was a rich prize, indeed. Loaded to the gunwales with silks, spices, jewels, gold, silver and many other exotic treasures, the *Quedagh Merchant* more than made up for the dearth of prizes that Kidd and his crew had experienced. The captain of the Muslim-owned ship—who was, ironically, an Englishman—eventually made his way back to Britain and told all who would listen about the dastardly piratical activities of Captain William Kidd. The British East India Company, whose dealings with the non-Christian world were complicated and often tense, was not pleased in the slightest.

By this time, after its long service in warm ocean waters, the *Adventure Galley* was a leaking, *Teredo* worm–eaten hulk. Sailors had to constantly man the pumps just to keep it afloat. Kidd decided to burn it and take the *Quedagh Merchant* as his new flagship. He renamed it the *Adventure Prize* and set sail for Madagascar to refit and plan his next moves. Who should he find anchored in the harbor when he made it there? None other than Robert Culliford, the notorious pirate who had stolen Kidd's original ship years ago back in the Caribbean. There are conflicting tales about how Culliford and Kidd interacted in Madagascar, but the end result was that several of Kidd's crew

decided to take their share of the prize and ship with Culliford back across the Atlantic to New York.

Rumors reached Kidd in Madagascar that Belomont and his sponsors in England now considered him to be a pirate, and he began to have second thoughts about the wisdom of returning to New York. He prudently decided that a sunny sojourn in the Caribbean might give him a little breathing room. It would allow him to test the political waters before returning to the colonies and the much-missed, loving arms of his wife. So he sailed the huge, ungainly *Adventure Prize* across the Atlantic and found that the governors of the English islands had declared him a pirate with a bounty on his head and that the Royal Navy was hunting high and low for him. He captured a sloop named the *San Antonio* and sailed in company with it to the obscure island of Mona, where he camouflaged the *Prize* as best he could and began to transfer the remaining treasure to the smaller, more manageable sloop.

Kidd completely abandoned the *Adventure Prize* and sailed north to meet his fate. Unsure of his welcome in New York, he took refuge on Gardiners Island and Block Island while he attempted to determine where he stood in the ever-shifting sands of politics and economics that swirled around the English colonies in the New World. During this time, a few weeks in the early summer of 1699, Captain Kidd, his legends and his treasure became inexorably woven into the fabric of Connecticut's history. We know for sure that some of the treasure that Kidd shipped on the *San Antonio* wound up on Gardiners Island. Just what happened to the rest of the captain's treasure is something that continues to form the basis of dreams and conjectures today. The gold, silver, silks and sundry that eventually were retrieved from Gardiners Island and duly shipped to Belomont in Boston account for only a portion of what Kidd supposedly brought to Long Island Sound with him.

Contemporary accounts detail the arrivals and departures of several small sailing and rowing vessels from Connecticut ports to and from the *San Antonio* while it lay at anchor in Long Island Sound. The purposes and destinations of these vessels are now lost in the mists of time and telling, but even today, more than three centuries later, many believe that they crossed back to the Connecticut coast laden with the riches of the East and that sundry treasures were buried in a series of locations along the shoreline and the Connecticut River. Interestingly, a vast volume of myth and legend grew in association with these supposed Connecticut treasure hoards. They provide a fascinating look at the ways that stories replicate themselves across centuries and even millennia.

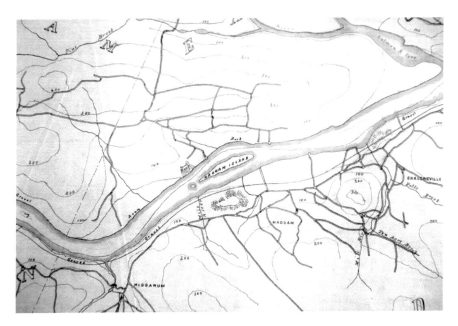

Haddam Island in the Connecticut River is one of the places where hopeful treasure hunters still search for Captain Kidd's treasure. *Photo by Ray Guasp, courtesy of the Connecticut River Museum.*

It is a proven historical fact that Kidd did bury or store treasure on Gardiners Island. He lavished gifts on the Gardiners for the privilege of stashing a considerable amount of valuables on their property. He warned them that terrible things would befall them should they dig up the treasure or divulge its whereabouts to another party. These threats held no terror, however, because when Kidd finally sailed to Boston, he was immediately arrested by Belomont. Hoping to satisfy his investors and win his freedom, Kidd arranged for the governor to retrieve the riches from the island lying off the coast of Connecticut.

Indeed, the riches retrieved were of considerable value. The official inventory, which did not factor in several light-fingered handlers involved in the transfer, lists more than a tidy trove of treasure. The crooked colonial politician retrieved almost eight hundred ounces of gold, more than six hundred ounces of silver, damask cloth, gold fabrics, silks and a sizable quantity of jewels. This would have been enough to clear Kidd's name in ordinary circumstances, but the unstable political and commercial climate of the times did not make that option a possibility. Kidd was arraigned for piracy and murder in Boston and shipped as a

prisoner back to England. He was summarily tried and then hanged for his many indiscretions and crimes.

Yet many still believe that Kidd did not bury all his treasure in one place. He was thought to have held most of it back in case he had to up the ante to bribe his way out of hot water. Other theories conjecture that he worked in consort with his wife to secret their wealth in the event that his case went against him. It was known that he was with her on several occasions while he was on Gardiners and Block Islands before he sailed into Boston and then eternity.

Gardiners Island was part of Connecticut until 1655, when it became annexed to New York. Its original English settler, Lion Gardiner, was instrumental in founding the Connecticut Colony and defeating the Pequot Indians in the war that was precipitated by the death of Captain Stone. His family has owned and governed the island as a personal fiefdom since the early seventeenth century. Kidd's treasure, of course, plays a large role in their family history and the lore of the island.

One of the stories of Kidd and his treasure transcends the span of Long Island Sound and brings one of his jewels to the shores of Old Lyme, Connecticut, within the context of an early eighteenth-century love story. According to written diaries and memoirs of both families, the Gardiners and the Griswolds of Old Lyme, Connecticut, were united in matrimony with a dazzling William Kidd diamond as a centerpiece of their love. According to a family story passed on for centuries, when Kidd was burying his treasure on their island, one of the Gardiners slipped a multi-carat gem of great value out of the pile of riches and hid it in a well bucket until the pirate and his posse had left the island. A few years later, the reclusive bachelor, who was the current lord of the manor, fell in love with Sarah Griswold, a noted Connecticut beauty. Sarah had been blown ashore on Gardiners Island while out for a day's sail when an unexpected gale blew up. Even more unexpectedly, the scholarly recluse who reluctantly invited her and her stranded friends to dinner fell head over heels in love with her.

A short time later, Gardiner dressed a retinue of forty oarsmen in fancy livery and had himself rowed across Long Island Sound in about as grand a style as possible. As soon as the bow of his barge touched the sands of Griswold Point in Old Lyme, he leaped ashore, wetting his kidskin boots in the process. He resolutely marched to Sarah's house. She was a bit astonished to see him there, tricked out in all his finery. He announced his burgeoning love for the lass, got down on one velvet-encased knee and held out Kidd's diamond as a token of his ardor and the hope of their betrothal.

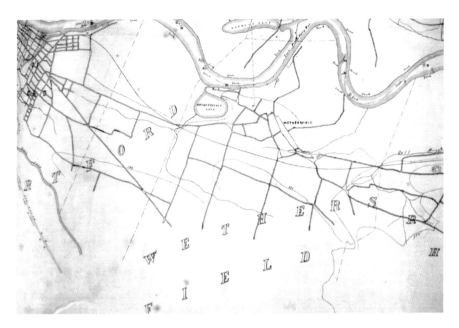

Wethersfield Cove is also believed to be a possible repository of Kidd's pirate gold. Would-be treasure hunters reported that strange apparitions and noises prevented them from finding the loot. *Photo by Ray Guasp, courtesy of the Connecticut River Museum.*

She said yes. They were married after a brief engagement, and Sarah and her diamond sailed across the Sound, where she became the mistress of a very grand manor, and they lived pretty much happily ever after.

Given its proximity to Gardiners Island, Old Lyme became one of the first places where Kidd supposedly buried a portion of his precious metals, minerals and fabrics. The legend persists to this day that near a spot called Lion's Rock (presumably named for Lion Gardiner) there resides a considerable cache of coins and other riches. The Lion's Rock treasure is one of the first of many stories that grew up around the Kidd treasure. These fanciful tales often include a supernatural being that guards the treasure and keeps it out of the hands of interlopers. This is an extremely ancient mythological motif—the monster that keeps watch over piles of wealth. The dragon keeping watch over the Golden Fleece is an early example of this motif.

The frightening, fantastical fellow that supposedly watches over the treasure-trove at Lion's Rock takes the form of a hideous demon. He is often described as having multiple heads and favors dispatching his victims by devouring them whole. This particular demon, however, has one glaring weakness. Inasmuch as Dracula can be defeated by sunlight, the Lion's

Rock demon cannot bear to hear even one word of the scriptures read aloud. There is an interesting print from the early nineteenth century that depicts two slaves in search of the treasure. One of them is reading from an exaggeratedly large Bible, while the other digs with a shovel. The demon cringes in the distance, helpless to interfere. A white male, undoubtedly meant to portray the slave's master, sits on Lion's Rock and has a faraway look, probably contemplating the life of ease and luxury that he will enjoy when the treasure is in his grasp.

The Connecticut River has become a repository of legends that have Kidd either sailing up as far as Windsor in the *San Antonio* or being rowed upriver in ship's longboats and yawls. Hundreds of people have spent thousands of hours searching for his elusive stashes. Sites believed to possibly be the place where Kidd did his hoarding include Lord's Island, Haddam Island, Middle Haddam and Haddam Neck. The Haddam Neck treasure was supposedly buried by two faithful crewmen and is guarded to this day by the petulant ghost of Captain Kidd himself.

Farther upriver, the town of Wethersfield (founded by John Oldham, also of Pequot War fame) has been long believed to be the treasure's resting place. Generations of would-be treasure hunters claim to have been frightened off their quest by strange and terrifying noises and apparitions. One digger reported that he was confronted by the shade of none other than William Moore, the seaman whom Kidd killed with a bucket in a fit of rage. Even farther upstream, just over the Massachusetts border, Clark's Island (over the years, popular usage has changed its name to Kidd's Island) is another purported treasure spot. It has been dug over by hundreds of people but has never yielded even one piece of eight.

The Clark's Island treasure is guarded by the ghost of a sailor. According to the legend, after Kidd and his party buried their booty, the crew drew straws to see who would remain on the island to keep watch over the loot. The sailor who drew the short stick was promptly shot and buried beside the treasure chest, his ghost under strict orders to see that the gold stayed put. In another version of the Clark's Island story, the treasure is guarded not by the shade of a sailor but by the ghost of "a beautiful Creole girl" whom Kidd and a sailor named Miles Braddish had kidnapped in the West Indies and brought north with them. According to this story, they buried the gold and the girl in the same grave so that the treasure "could be watched over by the spirit of her who was once a guileless maiden on the earth."

Sometimes the alleged treasure was guarded by more earthly beings. When I was a young lad in the middle of the twentieth century, my family

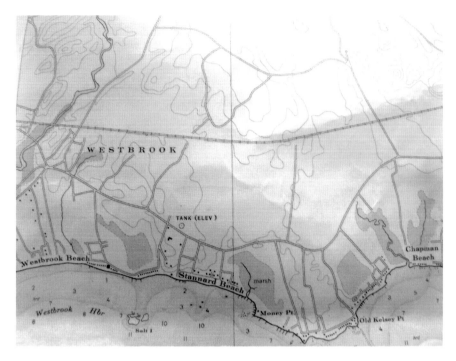

An eccentric college professor dug for Kidd's treasure for years at Money Point in Westbrook, Connecticut. *Photo by author.*

summered in Westbrook, Connecticut, at a beach called Money Point. The point naturally got its pecuniary name from the belief that it was where Captain Kidd buried some of his treasure. One beachfront property owner was a prominent professor of history at a very prestigious Connecticut university. He purchased that particular property based on his research and his unshakable belief that Kidd's treasure was to be found within its confines. Every day, all summer long, he could be seen digging at various locations on his land. Low tide usually found him sifting the clam flats with a spade. He was a bit of an eccentric, to say the least. We kids would torment him by gathering at the edge of his property line and scampering around below the high-water mark. His response was to wave a shotgun he claimed was loaded with rock salt and threaten us with extremely painful backsides—gun laws were different then. If he ever found any treasure, we never heard of it.

Up and down Long Island Sound, from the New York to the Rhode Island borders, tales of Kidd's golden trove abound. The sands of Clinton's Coburn Island and Hammonasset Beach are possible places where it could be. The Thimble Islands in Branford boast an island named Money, as Kidd supposedly

visited and deposited some riches. The captain of the Thimble Islands ferry (which also serves as a tourist boat) claims that there is a rock on Money Island onto which is inscribed initials that match those of one of Kidd's mates.

Farther down the Sound in Norwalk, a Civil War veteran claimed to have dug up a hoard of Spanish gold coins. Residents at the end of the nineteenth and the beginning of the twentieth centuries reported that in his dotage, he would occasionally display some of the coins to children in his neighborhood. Charles Island in Milford is another place that Kidd's legend inhabits. In fact, it has a citywide Captain Kidd celebration every year to honor the past and liven up the present. The island has been dug over so much by treasure seekers that it has suffered serious environmental damage to its topography, flora and fauna. Residents still tell the chilling story of two men who found two large treasure chests on the island only to be set upon by a hideous, flaming monster dive-bombing them from the sky.

The legends also make their way east down the Sound, ending at Lambert's Cove in Stonington, just on the Connecticut side of the Rhode Island border. Kidd sailed past Stonington on his way to Boston, never to return to Connecticut or the Long Island Sound. After he was returned to England and hanged, his body was wrapped in chains and displayed prominently on the banks of the Thames as a memento mori and a stern warning to passing mariners of the inevitable consequences of choosing the pirate's path. His ghost, however, lives on in the legends and lore of the Nutmeg State, as well as in the hearts of those who dream of riches beyond imagining that lie beneath the shores of Connecticut.

BLACKBEARD

To this day, Blackbeard fulfills the image of an archetypal pirate in our popular imaginations. His very name and image conjure the golden age of piracy. His legacy is enshrined in the very quintessential sense of what a buccaneer should look like and how he should act. We imagine him in his long velvet coat, three pistols hung in bandoleers about his person, a cutlass in his hand and fearsome fuses of sulfur burning in his beard to intimidate his crew and victims. Blackbeard, indeed, encompasses much of what has become the popular picture of pirates in the twenty-first-century's mind's eye. Although he is primarily associated with the Carolinas and the Caribbean, there is a persistent story of a treasure-burying foray that he made into Connecticut at one point in his piratical career.

Blackbeard's real name was Edward Teach (or Thatch, along with many other variant spellings of his surname). He was born into a middle-class family in Bristol, England. Like many a wayward pirate before him, young Edward had his sea-raiding skills honed during his service in privateers during Queen Anne's War. He settled in the buccaneer-infested Bahamas and joined a consortium of pirate crews under the overall command of the famed captain Benjamin Hornigold. In 1716, Hornigold appointed Teach as captain of a prize sloop that the two had captured. Thus elevated to command status, Blackbeard retained the rank of captain throughout his buccaneering career. He also partnered with pirate Stede Bonnet and, between the two of them, took many prizes in the Caribbean. Upon Hornigold's retirement, Teach became first among equals with his fellow skippers and assumed the role of overseer of their fleet of freebooters. Since pirate captains served at the pleasure of their crews, Teach was noted for his fairness as a leader and was consistently elected to the highest shipboard ranks. This spoke equally well of his administrative skills in handling crews of free-spirited sailors and his ability to keep them awash in rum and prize money.

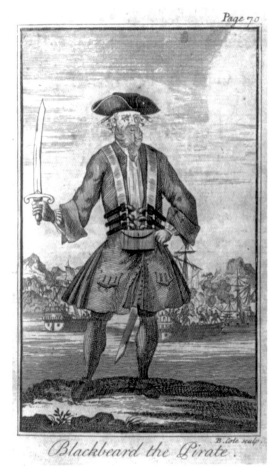

At one point, he captured a large merchant vessel and rechristened it the *Queen Anne's Revenge*. This is the ship with which his name is most often associated. Teach then began to center his corsair's career in the waters of the Carolinas. He recruited a cadre of like-minded pirates and terrorized the city of

Blackbeard's ferocious image marks the archetypal pirate. *Library of Congress.*

Charleston, South Carolina. He successfully attacked and disrupted shipping up and down the Atlantic seaboard, seeming to operate at will and on a whim. As a result of the complicated relationships between pirates and governments, he once received a royal pardon for his piratical activities. The fierce corsair then settled down with an astonishingly rich trove of ill-gotten gains to live the patrician life of a colonial country gentleman. But a quiet life of farming and contemplation soon became boring. Inasmuch as the freebooting spirit was in his blood and its call wasn't to be denied, he was soon back at sea with his piratical powers and ambitions intact.

His ongoing series of insults and depredations to colonial commerce proved to be most displeasing to the governor of Virginia, Alexander Spotswood. Determined to put a stop to Blackbeard's bad behavior, Spotswood commissioned Lieutenant Robert Maynard to assemble a crew of fearless tars and write the end to the tales of Teach's transgressions. Maynard successfully hunted down Blackbeard's ship. He and his crew were able to board the pirate ship, securing it with grappling hooks. Like the pirates, they were armed with flintlock pistols and cutlasses. Fierce hand-to-hand combat ensued. Naval men and pirates alike hacked one another to pieces and fired their weapons at point-blank range. At the end of the day, though, Maynard and his men were triumphant.

The images of Blackbeard's death are as vivid as those of his life. He was shot several times with pistols and muskets. His body was lacerated with a score of deep cutlass wounds, yet the fearsome felon fought bravely on, seemingly refusing to die. It was not until the sharp steel edge of Maynard's sword severed his head completely from his body that Edward Teach gave up the struggle and his spirit departed this world. An engraving of his head attached to the bowsprit of Maynard's boat as a grisly trophy remains a popular image. Like the picture of Captain Kidd's rotting corpse hanging in chains at London Dock, it serves as a reminder of the unfortunate end that many pirates ultimately suffered.

Captain Teach's connection to Connecticut is loosely based on the fact that he roamed as far north as New England in his efforts to take prizes and avoid capture. The persistent story that places him in the Nutmeg State claims that he visited these shores to bury some of his booty. Treasure hunters have long speculated that at one point Blackbeard appeared in New London and that he and his crew marched several miles inland, on a track that led to Boston, with a cache of gold, silver and jewels. It is believed that he and his men dug an elaborate, granite-walled excavation and deposited their treasure therein. He solemnly swore his fellow conspirators to secrecy, infusing the ceremony with the

usual "pain of death" caveats regarding the hiding place. They then returned to their vessel to sail south and meet their fate at the hands of Lieutenant Maynard.

During the nineteenth and early twentieth centuries, several treasure hunters, inspired by this story and dreaming of vast riches, made digs at various sites in the Hampton, Connecticut area. But nothing was ever found, and enthusiasm about the story and the potential discovery of a fortune waned. That all changed in the spring of 1938. Late one night that year, an eccentric, reclusive old bachelor named Cady answered a knock on his door. Although usually a crotchety, hermetic sort and wary of strangers, Cady opened the door all the same. For some reason that remains unknown, he took an immediate liking to Barney Reynolds, the mysterious stranger who appeared late that evening. In a show of hospitality that was totally foreign to his nature, the hermit opened his home and invited Reynolds in for some coffee and conversation.

Barney Reynolds then unfolded a fantastic tale to the increasingly interested Cady. The stranger claimed to be a direct blood relation of the buccaneer Edward Teach. After establishing these bona fides in a somewhat believable fashion, Reynolds, to Cady's amazement, then unrolled what appeared to be a very old parchment map that, the wayfarer claimed, showed exactly where Blackbeard's treasure was buried. Even more amazingly (from Cady's point of view), the details of the map—a horsehead-shaped stone, a boulder that had been marked by metal instruments, a bend in a brook and a rock that had been carved into the shape of a fish's head—all were coordinates and waypoints that led to the exact location of the treasure.

Cady instantly recognized all the landmarks that Reynolds pointed out on the map. He had always believed that the markings on the rocks had been crafted by Indians, but these sites were truly located where they were shown to be on the mystery man's ancient chart. Here the story takes a somewhat fantastical turn, as if it weren't fantastical enough. According to an oral history that Cady attested to several years later, Reynolds proposed that if Cady were to provide him with some digging tools and give him complete privacy while he was digging, the man with the map would split the considerable profits of the treasure with him half and half. Cady claims to have readily agreed to these somewhat suspect conditions. The next morning, Reynolds, armed with the landowner's pick, shovel and pry bar, made his way into the woods to where the booty was supposedly buried.

The day went by and then another. Although Cady had agreed to let Reynolds work in private, his curiosity got the best of him, and he trudged out through the woods to check on the progress of the dig that was going to make him wealthy beyond his wildest dreams. But alas, his vision of riches was not to

be. When he made his way to the spot marked by the proverbial X, there was nothing but an empty hole, five feet deep and eight feet wide and lined by granite walls smooth and clean. Lying next to the pit were some splintered timbers and a large stone that had apparently covered the mouth of the excavation for more than two hundred years. Cady's tools were at the bottom of the pit, as were a pair of old, muddy boots…hardly the booty that Cady had envisioned that he would hoard and spend at his leisure well into his old age.

What was missing, of course, was any sign of Reynolds or the treasure. He was never seen again. It is up to our imaginations as to whether he made off with a vast fortune or not. If he found it, how was he able to carry it out undetected? Did he have confederates lurking in the woods to help him with the logistics and lugging? Was he just a figment of Cady's imagination, perhaps fueled by loneliness or strong drink? People who knew him said that Cady was a pretty reliable, straightforward man, not usually given to falsehoods or flights of fancy. For years he willingly displayed the granite-lined hole where the treasure was purported to have been to those curious about his story. Like many good pirate sagas, this one trails off into mystery. Most likely it will never be fully resolved.

Mooncussers

Not all of the unfortunate ships that were pirated and plundered in the seventeenth and eighteenth centuries in Connecticut were taken by other ships at sea. Sometimes a ship and its cargo would be ravaged by larcenous land dwellers after it had run aground or was washed ashore during a severe storm. In certain circumstances, land-based maritime disasters were intentionally created by nefarious groups of coastal dwellers called mooncussers, or wreckers. They disliked the bright light of a full moon because it gave mariners the ability to see better at night and thus avoid the perils of reefs and rocks. Wreckers could be found on rocky coasts the world over. Those who preyed on helpless and injured grounded vessels would sometimes set false lights in the hopes of confusing the watchful eyes of those navigating close to shore. Like the fine lines between privateering and piracy, there were often blurry distinctions between wreckers and salvagers. Salvagers would often aid in the rescue of stricken vessels. They often had legitimate claims on the cargo, rigging and fittings washed ashore from damaged ships.

One of the most interesting examples of land-based maritime thievery of a vessel's goods occurred on the shores of New London, Connecticut, between 1753 and 1754. The sequence of events that occurred makes for a ripping good tale. They combine the recurring themes of buried treasure guarded by supernatural beings and the mysteries of why these treasures are rarely, if ever, recovered. Like the story of the Dutch pirate David Marteens, it involves a Spanish galleon and a vast treasure-trove of gold and silver. The galleon in question was named the *Saints Joseph and Helena*. Its last voyage found it outbound from Havana, Cuba, on its way to Cádiz, Spain. Its capacious holds were heavily laden with a very valuable cargo of gold bars and ingots. The treasure was under the supervision and watchful eyes of the ship's supercargo, Don Joseph Miguel de San Juan.

The gold-stuffed galleon suffered severe damage in a hurricane-like storm. Its prudent captain decided to put into the port of New London to make the necessary repairs to allow the big Spanish freighter to continue on across the Atlantic to further enrich the increasingly needy treasuries of Spain. That perennial power in the New World was by then losing its grip in terms of North and South American hegemony and desperately sought every ounce of treasure its colonies and galleons could provide. Unfortunately for the *Saints Joseph and Helena* and its unlucky crew, it plowed hard into a reef off the Connecticut shore and required even more complicated repairs than originally anticipated before it could proceed on its plodding voyage back to Old Spain.

It was determined that the ship would have to be careened to effect the requisite repairs. Careening is a process whereby a ship is beached and then tilted over on one side in order to fix the gashes and other damage to its hull. To accomplish this, it was necessary for a considerable part of the *Saints Joseph and Helena*'s valuable cargo to be offloaded from the stricken ship and stored in a supposedly secure spot in the prosperous and bustling port of colonial New London. The port collector, Joseph Hill (like the ship's eponymous saint, men named Joseph play important roles in this story), took charge of the project from the Connecticut colony's end to ensure the security of the gold and silver. From that point on, the tale grows more complicated, increasingly fascinating and far less believable.

It should come as a surprise to no one that somehow a goodly amount of the tantalizingly tempting treasure mysteriously turned up missing. Naturally, the outraged, indignant Spanish captain raised a clamorous hue and cry to any and all who would listen. The apoplectic officer blamed the black-hearted townsfolk for the theft. He reserved a vast volume of vituperation for the feckless port collector, Joseph Hill. He loudly accused anyone and everyone within shouting

distance of grand theft, fraud, larceny and crimes against Spain. The nonplussed Hill responded by saying that he did everything humanly possible, and more, to keep the precious ingots and coins secure and that he had no idea how they could have vanished into thin air. This explanation, or lack thereof, did not at all satisfy the aggrieved Iberian officer. Among the general populace of New London, some skeptical eyebrows began to be raised, and some increasingly incredulous tongues started to wag among its more gregarious gossips.

To seek redress for this injustice, the self-righteous supercargo De San Juan solicited the Connecticut General Assembly for compensation to replace the value of his missing lucre. The legislators, ensconced far away in Hartford, decided that since they had nothing to do with the lost loot, the requests of the Spanish ship's officer were unreasonable. And yet they decided that Miguel de San Juan was worthy of "the protection of a foreigner cast among us" (my how times change). He was, in fact, recompensed almost totally for his losses. The duly chastened port collector was harshly admonished and censured for his inability to safeguard the property put under his care. The Spanish sailors collected their compensation, the *Saints Joseph and Helena* was finally repaired and off los marineros cheerfully sailed to Cádiz.

But the story does not end there. More than seventy years later, in 1827, the grandsons of a necromantic old woman named "Granny" Marm Strickland gathered at their grande dame's hearth to hear an extraordinary tale. The high-spirited young men leaned close to the ancient crone when she whispered that she knew where the galleon's vast treasure was buried. Strickland was revered as a practicing witch in the grand tradition of supposed New England broom flyers. In her younger days, she had been banished by both the Connecticut and Massachusetts colonies, finally alighting in Vermont, which, apparently, harbored more tolerant attitudes toward the practice of supernatural activities.

The wrinkled old witch Strickland had a hoard of magical pebbles. These stones were as clear as fresh spring water and enabled her to look, crystal ball–like, into both the past and the future. These translucent bits of magical geology were especially effective when it came to divining where hidden and buried treasures were to be found. According to her variation on crystallomancy, she could see boxes of coins lined up with their edges precisely aligned. Her visions also included several crates full of bars of gold. These valuable caches of precious metals, according to her miraculous machinations, were buried in New London, Connecticut. They had lain there untouched for decades, just waiting for her gullible grandsons to do a little excavation and retrieve them.

With a theatrical wave of her witch hazel wand, the divining crone sent the lads south with a hand-drawn map that indicated the whereabouts of the goods. The map showed that the treasure was to be found under a rickety, crumbling old wharf that was now grown over with grass, weeds and barnacles. In the small, quiet hours of very early morning, the brothers made their wary way to the water's edge by lantern light and began to wield their pick and shovel. The hole they dug quickly began to fill with water, making digging almost impossible. Hot, tired and discouraged, the young men were just about ready to give up their work as folly and seek some liquid refreshment when their spade struck something hard, its metal exterior sparking against the shovel's edge. It was an ironbound chest! Grandma's visions appeared to be valid.

It is here that the tale becomes a bit fantastical. As they stooped down to lift the heavy metal box out of its hole, much to their amazement, they found the iron too hot to handle. They then began to hear the sound of deep growls, and the apparition of a giant dog appeared in the mouth of their pit. This chthonic canine was terrifying to look at and didn't seem to be the least bit friendly. Red eyes began to flash all around them in the darkness. And if that wasn't enough to scare them off their pursuit of riches, a huge wild goose, with eyes of blazing green, hovered above them hissing horrible curses at them. Their gramma had promised that they would be safe, but these hideous haints were too much for the intrepid treasure seekers; they dropped their tools and departed in a very hasty fashion.

The dispirited brothers made their way back to Vermont and tried to get Witch Strickland to return with them to New London to conjure up some spells that would keep the demons at bay while they retrieved the loot. Granny could not be persuaded to return to Connecticut, however. Having avoided being hanged there once, she did not want to press her luck a second time. The boys tried to convince her that the laws against practitioners of the black arts had changed, but to no avail. She would not leave the sanctuary of the Green Mountain State. She did, however, provide them with some amulets and spells that she claimed would ward off the horrible horde of gold guardians.

With some doubts and trepidation, the boys wound their way south to New London again to take another crack at the cache. Their trip was in vain. Upon their return to the overgrown dock, there was no evidence of their original excavation. They dug a fresh hole, but there was no sign of the iron chest or the specters that surrounded it. To this day, no one has ever claimed that they found the *Saints Joseph and Helena*'s fabled treasure. Perhaps only the shade of Port Collector Hill knows the true location of its shining riches.

Part II

Privateers

The Earl of Warwick

In his seminal biography, *Captain Kidd and the War Against the Pirates*, historian Robert Ritchie called Robert Rich "the ubiquitous Earl of Warwick." Indeed, he did seem to be everywhere in the first half of the seventeenth century. He was a man of great influence and many interests. He was a courtier, a revolutionary, a high lord of the admiralty, an adventurer, a colonizer, a visionary and a statesman. Robert Rich, the Second Earl of Warwick, was an English original. Among all his titles and functions, one stands out: he was a consummate privateer. As we shall see, the earl was instrumental in the founding and development of the Connecticut colony, and he imprinted it with a sea-roving legacy that shaped the watery history of its early days in a roistering and quasi-legal fashion.

The Earl of Warwick had interesting antecedents. His great-grandfather was a canny lawyer who lacked principles but had keen survival instincts and sharp business and political sense. He aligned himself with King Henry VIII's crusade to separate the English church from Roman Catholicism and supported the monarch's divorces. He accrued a considerable estate in the process. After Henry's death, the earl became adept at switching sides and surviving; he continued to be styled as a royal "councillor" until his death.

The earl's grandfather increased the family fortune, and his father came into his inheritance at the tender age of twenty-two and took up the "lucrative Elizabethan sport of privateering. Whereby seagoing buccaneers,

licensed by the English crown, would prey on Spanish ships." In 1618, the grandfather paid King James £10,000 and became the Earl of Warwick. He proved to be lucky in business but not so much in love. He had an arranged marriage with Penelope Devereux, who inspired Sir Phillip Sydney to write some of his most famous romantic poetry. They had seven children but weren't very happy. She began to flaunt an affair with Lord Mountjoy, and the earl finally had enough and separated from her.

His firstborn son, who figured so prominently in the formation of the Connecticut colony, received his education at Emmanuel College, Cambridge, a center of Puritan theology and upheaval. He followed his family tradition and studied law. He soon expanded into business, privateering and colonization. His lifelong dedication to Puritan ideals played an important role in shaping the religious and political sensibilities of the New England colonies and Bermuda, as well as the Caribbean and Central America.

Warwick found himself in some difficulty after one of his privateers attacked a ship belonging to a mogul from India that was under the protection of the East India Company. It resulted in years of litigation and caused a rift between him and the Virginia Company of which he was an officer, hence his involvement in the colonization of the New World. Barely escaping the necessity of fighting a duel over his privateering gaffe, the earl used his shrewd business and political acumen to become the head of the Virginia Company. He also became a founding member and the largest stockholder in the Bermuda Company, ensuring a long and remarkable career as a colonizer.

As the driving force behind the development of a colony on Bermuda, Warwick found it a convenient place to stockpile renegade Puritan ministers who were increasingly unwelcome back in England. As a result, he began to demonstrate a very public profile as a strong supporter of the breakaway religious movement. His involvement with the Puritans would play a key role in his involvement with the fledgling Connecticut colony and the subsequent proliferation of privateering there. The privateer model that he adopted in England would prove to be an important part of the economic foundation of New England. Connecticut's presence on Long Island Sound connected it to the Massachusetts Bay Colony and the Dutch of New Amsterdam, as well as gave it access to the eastern seaboard and the Caribbean. The lessons he learned in establishing Bermuda gave Warwick a framework for the founding of Connecticut.

In the early seventeenth century, Warwick joined the Guiana Company. Started by Sir Francis Drake, its purpose was to establish a colony in that

South American country. It was eventually decided that it was not a great location for a colony. As it was too hot, too close to Spanish military power and noted for a pestilential environment, the company abandoned that approach and instead opted for Virginia. Conveniently, Warwick was also a member of the Virginia Company.

But when the Pilgrims landed in the New World, it was outside the purview of Virginia. They wound up a bit north, in New England. Fortuitously, the ubiquitous Warwick also happened to be a founding member of the Council for New England. He became a signer of the Bradford/Warwick Patent, which gave land to the Puritans if they could stick it out in the relatively harsh climate of Massachusetts. As he gained political prominence for his efforts, he became the framer of the Connecticut Patent, which led to the establishment of a colony at the mouth of the Connecticut River under the auspices of Lord Saye and Sele and Lord Brook. While some today doubt the existence of the Connecticut Patent, it served as a legal basis for a government in the colony and hence became an instrument that resulted in the granting of letters of marque to privateers.

Warwick's engagement in privateering activities quickly crossed the Atlantic and became an active practice early in Connecticut's history. The English settlers vied for control of the territory with the Dutch, as well as for economic and political gain with forays and seaborne attacks on the French and the Spanish. He also carried on decades of privateering and piracy in the Caribbean and South America in conjunction with his attempt to colonize New Providence Island on the Mosquito Coast. His attacks on Spanish land bases and ships put him increasingly at odds with Charles I, the English king. Parliament, however, approved of his activities, and he was named lord high admiral of the Royal Navy.

He played an important role in establishing English hegemony in New York and New England. The city of Warwick, Rhode Island, was named for him. His prescient opposition to the Spanish and the Dutch gave his colonies the seagoing power to become increasingly important economic and naval entities as the New World evolved. The Warwick Patent established the English as the preeminent power on the Connecticut coastline and on the Connecticut River. His legacy of privateering lasted from the middle of the seventeenth century to the beginning of the nineteenth.

A QUOTIDIAN CRUISE

Not every minute of a pirate or privateer's life was filled with life-and-death battles, chases, captures, shipwrecks, political intrigue and general mayhem. There were often long stretches of relative boredom and practicality while the basic logistical needs of the ship's upkeep required attention. There were also long stretches of time when no sails were espied, reducing the chance for prize goods and money to zero. And not every sail that loomed over the horizon was potential prize material. Some proved to be friendly to the corsair's cause and sometimes joined forces with its captain and crew. Many Connecticut privateers cruised in company with like-minded vessels. In other cases, sailing ships—some friendly, some not—were simply too speedy to allow the privateer to run them down and determine their status. These factors combined to give sailors a lot of downtime, which captains and mates filled with endless rounds of ship maintenance involving carpentry, cordage, coopering, holystoning, swabbing, chipping, scraping, painting, rerigging and resupplying. The sailors would also have free time to devote to their beloved pipes, the spinning of sea stories and the occasional fight or frolic.

The logbook of the privateer *Dolphin*, now in the collection of the Mystic Seaport Museum, lends some insight into the everyday life of a privateer and its officers and crew. There were practical tasks that existed along with some of the seamanship challenges presented by bad weather, as well as hostile interactions with other ships and land-based targets. The events that the officers chose to include in the daily script of the ship's activities present a balance of the mundane with the exciting. They also reveal a relationship between privateering and slavery, a relationship that resonates with the long-established trade relationships between Connecticut and the West Indies. This little-known connection to slavery reflects poorly on the privateering profession, at least when viewed from the sociocultural lens of the twenty-first century.

The *Dolphin*'s homeport was Stonington, Connecticut, the village that lies at the far eastern end of the Connecticut shore. It was under the command of Sanford Billings. The Billings family was part of the southeastern colonial Connecticut community almost from its inception in the middle of the seventeenth century. Captain Billings's family includes many ship's captains and owners. They owned and bonded privateers in both the Revolutionary War and the War of 1812. Their seagoing activities in the area lasted well into the twentieth century as they captained Stonington draggers, which fished for steadily decreasing catches of cod and flounder.

The *Dolphin*'s remarkably well-preserved logbook documents a cruise that began in November 1762 and continued through March 1763, revealing a

litany of fascinating details of everyday shipboard life. It also offers a series of interesting insights into the geopolitical situations that were roiling the waters between North America, the Caribbean and Europe at the time. The Stonington privateer had to navigate some very tricky diplomatic waters, as well as the hazards of Cape Hatteras and the crystal-clear seas of the Caribbean.

One of the most obviously necessary and important tasks that challenged ship's officers was the recruitment and retention of a good crew. Captains were often in fierce competition with one another to fill their ships' companies with the best available tars. The monetary rewards possible from privateering sometimes made this task easier, but not always.

The dashing Simeon Haley was a privateer based in Mystic and Stonington, Connecticut. He served as a prize master and captain. ©*Mystic Seaport.*

Before-the-mast sailors have always presented some challenging personnel issues due to their footloose lifestyles, poor financial planning and management, tendency to jump ships that were not quite up to their liking and fondness for spirituous liquors. Labor and management were always engaged in a supply-and-demand juggling act pitting profits against wages and management against the rank and file. The monetary rewards that could be reaped from a privateering voyage were a powerful incentive to sailors to sign on for and complete a tour of duty. This high remuneration gave captains a leg up in securing a somewhat skilled and reliable crew for their (hopefully) moneymaking ships.

With the fitting out of his ship for its privateering cruise almost complete, Captain Billings had to fill a spot for a shipboard apprentice, as the lad he had signed on was suddenly taken ill. He managed to find a willing fourteen-

year-old denizen of the Stonington docks and easily convinced him to sign the ships' articles, luring him to venture out on the early winter New England ocean with the promise of adventure, glory and riches. The role of a lowly apprentice consisted mostly of scut work, serving the whims of the captain and officers, but it also held the promise of quick career advancement in a business that had heavy personnel turnover. It was also the first rung on the ratlines up the career path to able-bodied seaman and perhaps even captain at some point in the future.

The lucky lad chosen for the job was made to sign a document that resembles what we would call a Non-Disclosure Agreement today. The apprentice candidate had to swear that he "shall keep the company's secrets, and lawfully and cheerfully comply with all orders…and, above all, do no damage." One wonders what company secrets would filter down to an apprentice. It also seems a stretch to think that a young boy would cheerfully comply with all orders, especially those concerned with human and animal waste that could be pervasive aboard ship. With the hiring on of the new apprentice, the *Dolphin* had a full complement of crew and was ready to begin its voyage in search of prizes.

On a chilly afternoon toward the end of November 1672, the *Dolphin* "weighed anchor at Stonington with 32 men and 1 boye [*sic*] on board." The weather was not totally in the ship's favor. There was a moderate sea running, and the wind continued to build as the day progressed. Captain Billings decided to put into Block Island, a relatively short sail from Stonington, to wait out the weather and continue outfitting the ship for its foray. He sent his longboat ashore, and it returned with four barrels of water and a good supply of firewood. Fresh water, with its life-sustaining abilities, is the most important commodity on any ship. Billings, like all prudent captains, added to his supply whenever the opportunity to do so presented itself.

After a few days being weathered in on Block Island grew a bit frustrating, the *Dolphin* was anxious for some action, but it "couldn't put to see [*sic*], even under double reefs." But on November 27, the weather broke, and it was able to run down a schooner from New Providence that was full of molasses. The schooner was under the command of Captain Mumford. This was the first prize of the voyage, and such an early success would have greatly heartened the captain and his crew. Molasses was an incredibly valuable product in eighteenth-century New England. It is the primary ingredient used in the making of rum, which was a very popular beverage in the 1700s given the unreliability of the water supply. The New England colonists called it "Old Killdevil," and it formed the basis for much economic activity, including,

unfortunately, the Triangle Trade with Africa, which brought slaves to North America. Much of the commerce that came north from the Caribbean to Connecticut was centered on molasses and rum.

Two days later, the *Dolphin* spotted and chased another sail, but deteriorating weather and a foul wind motivated Billings to break off the chase rather than risk his ship and crew. He then decided to double back toward New London to obtain some "necessaries." On his way to that busy whaling port, he "spoke a snow from Savannah, Captain Hall, master." He also gave a brief chase to a "briggantine." His pursuit proved to be in vain due to the superior speed of the other vessel. The weather also made it an exercise in futility to continue the chase, so he put into port to supplement his victuals, wood and water supplies.

With the coming of December, more prize opportunities revealed themselves. On the second day of that month, the *Dolphin* chased a sail all the way from Fisher's Island to Block Island. After finally running it down, Billings ordered it to heave to, but it refused. The privateer captain then fired several shots across its bow, and it became much more compliant with his orders. It turns out it was "a coaster from Rhodeisland [*sic*] bound to Connecticut." Later that day, the *Dolphin* chased two more sail to the eastward, but they each had long head starts and neither came within range of its cannons. Billings then made for Naushon Island, one of the Elizabeth Islands that lie in a chain off the coast of Massachusetts. He established an anchorage base at Tarpaulin Cove, which remains a popular destination for yachtsmen to this day, although they are not permitted to land on the private island.

Operating out of this island refuge, he was able to intercept several transports that were trading between Providence and New York. But while doing this, his stores, ballast and water shifted in his hold (or "hole," as he phrased it). This required him to miss a day searching for prey, while his crew had to reposition everything in the hold and add a significant amount of ballast as well as four barrels of water. This was heavy work performed in dank, tight spaces, but it was necessary to ensure and maintain the seaworthiness of the vessel and the safety of the crew. Once the ship's stores and ballast were stowed properly, Billings tacked back and forth between Naushon and Martha's Vineyard, speaking a ship from "Meryland" but not encountering any potential prizes.

On December 6, this short dry spell was broken when he captured the brig *Mars* along with a schooner from Cape Cod. These were heavily laden, significant prizes, worth a lot of money in Admiralty Court. His morale and the morale of his crew were greatly uplifted by the prospect of a splendidly

remunerative payday. There was also a lot of time remaining on the cruise, which provided opportunities to increase the monetary rewards for the owners, officers and crew significantly. The capture of a ship so close to home was also a plus from a logistical point of view. It only required the necessity of a prize crew to be off the *Dolphin* for a relatively short period of time, enabling it to quickly continue its cruise in search of more prey.

During the following days, the weather turned nasty, and the wind kept up a steady thrumming as it whistled through the rigging. The *Dolphin* had little choice but to remain at anchor in Tarpaulin Cove. The crew was kept busy by endlessly ferrying barrels of water from Naushon Island and storing them in the hold in anticipation of sailing farther afield in search of more prey. Fresh water was always a concern on sailing vessels that might be becalmed or blown off course away from sources of this precious resource. Untold thousands of people died of thirst during the Age of Sail even though they were tantalizingly surrounded by endless vistas of water, all of it too salty to drink. The *Dolphin*'s sailmaker and carpenter were employed in repairing some damaged sails and spars to ensure that the ship would be ship shape and Bristol fashion for a long cruise to the south.

On December 9, the wind finally moderated a bit. The ship's papers of the brig *Mars* were brought on board the *Dolphin*. Possession of the *Mars* was formally taken, and it was put under the command of Billings's chief mate. At this time, a prize master was requested from Connecticut to secure the *Mars* in the proscribed legal fashion. The arduous, never-ending chore of taking on water continued throughout this process. Fortunately for the sailors so engaged, it was made somewhat easier to accomplish with less wind and somewhat smoother seas.

December 11, 1762, was a day of raucous good cheer aboard the *Dolphin*. Although the interminable tasks of wooding and watering continued, the *Mars* was officially turned over to a prize master, which was cause for a joyous celebration. The officers and crew "all drank in good health." More than a few did so to wretched excess, becoming as foggy as the weather, which was putting a damper on Captain Billings's plans for the continuation of his cruise. The following day, much to the relief of some of the more hung-over crew members, it was too foggy to weigh anchor for both the *Dolphin* and its prize. Perhaps as a result of some out-of-control, rum-induced hijinks, Billings found it necessary to fire the ship's carpenter, a key member of a crew of any ship that might sustain damage in battle. A competent carpenter was vitally important on a privateer; he would regularly be called on to

repair ships taken as prizes in order to make them seaworthy enough to sail to a port where they could be converted to money.

On the fourteenth, Captain Billings could no longer tolerate being idle, and the *Dolphin* put to sea in spite of the "dark and foggy weather" that persisted in Martha's Vineyard Sound and the Elizabeth Islands. Shortly after they were underway, the wind died completely, and the *Dolphin* wound up "drifting aimlessly off Gay Head." Becalmed to the point of having no steerageway, Billings grew alarmed as he noticed the barometer begin to drop precipitously. Correctly assuming that a major storm was on the way, he ordered that the "guns be struck down in preparation to guard against the storm in the best manner possible." This made the ship much less top heavy and much less liable to capsize in the heavy seas the captain anticipated.

The predicted storm proved to be intensely ferocious. It beat down on the *Dolphin* relentlessly. In addition to lowering his guns, the ever-prudent Billings "got the foremast down, got the flyingjibboom [*sic*] in" and wound up "scudding under one small, square sail." According to the ship's log, which usually understated things in the fashion of New Englanders, "the wind blew very hard." The gales of wind were now accompanied by hail, snow and rain, which made for some difficult work aloft, as the rigging froze and ratlines and footropes grew difficult to grasp and hold. But the crew managed to bend on the *Dolphin*'s storm sails, made with the strongest canvas and cordage. With its guns shipped and hatches battened down, it was able to withstand "the violent wind and sea." Captain Billings declared it to be "a good sea boat, through the goodness of God." He reported that "all hands were well, except some were sea sick." Thrashed about by "great seas," the *Dolphin* endured a winter hurricane; his description seems to portray the turbulence as a seventeenth-century version of the Perfect Storm. Remarkably, the only damage reported was "a split foresail," a testament to Billings's foresight and seamanship.

As the winter solstice approached, with its promise of lengthening days, the weather finally broke, and the *Dolphin* squared its rigging way and prepared to head south. Captain Billings put into New London briefly and shipped a new carpenter, as well as three more ordinary seamen. He also took this opportunity to take on some last-minute supplies. He then set a course for the Caribbean, having had enough of New England's winter hurricanes to last him and his crew for a good long time. January found him in the much friendlier climes of the Bahamas, where he met up with the privateer *Hero* out of Philadelphia. As was often the custom of privateers, their respective captains decided to cruise in tandem "hoping for a prize." Working as a

team, two vessels could sometimes outsail, outmaneuver and overpower a ship that would be too formidable to be taken by just one of them.

The beginning of February found the two ships searching for prey in the vicinity of Hispaniola (now Haiti and the Dominican Republic). On the tenth day of the month, they "saw a sail under the land, hove out our boat, armed her and sent to fetch her [the potential prize]. But she ran ashore, and they, having small arms beat off our boat with the help of a bad reef." The reef prevented the *Dolphin*'s boat from being able to get close enough to its target to capture the fortunate victim. The following day, the *Dolphin* itself ran aground while giving chase to a sail, but it was "able to get off without any damage."

On February 12, Billings wrote that "we saw a canoo [*sic*] on shore and found her to be a good canoo with about one barrel of fresh pork. The people [who were paddling the canoe] took to the bush and we went to anchor at the Tortugas. At 6 am we sent 10 hand on shore to look for wild negroes." This is a disheartening but interesting turn of events because it suggests that colonial privateers engaged in dubious aspects of the slave trade. The reason to capture free people of color could only have been to ultimately sell them as slaves at some point in their voyage. While they weren't engaged in the slave trade per se, they were apparently intent on kidnapping people in order to sell them. This unfortunate practice is rarely mentioned in the literature of privateering. It reminds us, though, that the maritime commerce between Connecticut and the Caribbean was carried on in symbiosis with the slave trade. Much of the foodstuffs and merchandise that made their way to the islands from the Nutmeg State wound up supporting the plantation culture in which slavery flourished. Conversely, sugar, rum and molasses, the products of slavery, enriched Connecticut's ship owners and captains.

Whatever their motives might have been (profit was probably high on that list), the crew of the *Dolphin* was ordered to resume its hunt for potential captives the following day. In very hot weather interspersed with pouring rain, they searched for their human prey but fortunately did not find any. They did spot a sail, though, and immediately took up the chase to capture it. Their shallow-drafted quarry sailed very close to the shore and came within the protection of a shore-based battery of cannons. The New Englanders were able to evade the cannon fire and get aboard it, though. After searching its cargo and passenger list for two hours, the Connecticut privateers, to their chagrin, decided that there was nothing of value to be taken from the hapless vessel and allowed it to continue on its way without further molestation.

On February 14, the crew had some singular success in its quest for people to sell as slaves. Crew members captured a canoe that put up some valiant resistance. One crewman of the *Dolphin* was moderately injured in the fray, but the rest were "all hearty." The unfortunate men of color in the canoe were immediately taken captive. The following day, another canoe came alongside under a flag of truce and ransomed the prisoners for a sum of silver. Whether they were ultimately sold as slaves by the people who ransomed them is unclear. At least the ransoming put to rest speculation that the "hunting of negroes" was for sport rather than profit.

The *Dolphin* soon joined forces with two other privateers and chased, and eventually overtook, a ship that proved to be the *King George* out of Virginia, under the command of Captain Smallwood and armed with twenty guns. They eagerly agreed to join in company with it and, along with its current consorts, formed a small flotilla of four vessels. At the sight of so many privateers converging near their coastline, two forts along the shore fired alarm guns to warn the inhabitants of the town of possible attack from the sea. The reputation of pirates to pillage and plunder land-based installations apparently also extended to privateers.

On the following day, in conjunction with a "Providence Privateer," a party of *Dolphin* sailors in a canoe chased an English ship into the range of the shore batteries. Why they were chasing a British boat remains unclear, but loyalties were confusing and malleable in the seventeenth century. The Yankee sailors had to lie flat in the bilges of their canoe, as cannon shot whistled menacingly over their heads. The crew members had risked their lives for naught, as the English ship proved to be in ballast and was sent on its way without being taken as a prize by the disappointed Connecticut sailors.

On February 18, the *Dolphin* anchored off Hispaniola and sent a canoe out in search of a prize or two. While the paddlers were out on the hunt, a stiff breeze came up and their small boat was "blown out to see [*sic*]." Observing their plight from the safety of their anchorage, the crew of the *Dolphin* hastily weighed anchor and raised its sails. The tiny canoe was difficult to spot among the rapidly steepening waves, and Captain Billings grew extremely concerned for the safety and well-being of his men and their equipment. But a sharp-eyed lookout up in the crow's-nest spotted the canoe a few miles offshore. It was in distress and taking on water, and the men of the *Dolphin* were able to report that they "found our canoe, which we were glad to see."

The next day, a sail was spotted, and the "Virginia ship with us" (presumably the *King George*) gave chase and ran the ship down. It proved to be from

Rhode Island, bound for Jamaica. Billings put his first lieutenant aboard it and ordered to beat up into "Manganeal Bay" (the spelling in the source is difficult to read). The *Dolphin* tried to keep up but wound up "beating up between the Cape and the Mount, but not able to see anything of the sloop." The prize was rediscovered the following day, but the weather began to deteriorate and became "very blowery…and our former comfort was very much shattered by heavy winds." Despite the weather, Billings ordered his crew to load up with wood and water, those all-important commodities, in preparation for "fitting out to sea."

As they were gathering the supplies necessary to extend their cruise, two of the *Dolphin*'s men sent ashore to gather wood came upon a "Frenchman, one negro and three mulattos." They captured these people, brought the people of color back to the ship and returned to the island in search of more human prey. They found the Frenchman and more people, but they ran away before they could be taken as prisoners. "We could not catch them. The bushes were too thick. The Frenchman gave us a considerable quantity of fresh port [wine perhaps] and small figs. We send our canoe to recapture the negroes, but they jumped out of the boat and ran away."

On the twenty-second, the *Dolphin* lay at anchor with its fellow privateers the *Hero of Philadelphia* and the *King George*. The companies of all three ships combined to "put together a band of 150 well-armed men and marched on the town. We captured 2 cannon and 6 swivel guns, 8 negroes and some small plunder." One crewman from the *Dolphin* was wounded with a musket ball to the shoulder, but he was the only casualty among the invaders. The logbook did not indicate how many, if any, of the town's inhabitants were wounded or killed.

Fortuitously, on the following day, news was received that changed the scope and nature of the *Dolphin*'s purpose and function, given the complicated politics of the times. "By the best account this day it is a general peace with England, France and Spain! All hands cleaning ship getting ready for return from our cruise! The Hero Ship and the King George sailed for home this day!" Apparently the *Dolphin* had run out of potential targets to pursue. Its crew was in high spirits in anticipation of "rolling home."

As this peace was declared long before the invention of radio, not all vessels in the vicinity were privy to this extremely important intelligence. In spite of the rumored peace, on March 3 "a ship beating through the anchorage hoists a French flag and fires a cannon shot. It misses our quarter by 2 rods. We fire back and the French ship hauls down her colors and sails away." The French ship must not have heard about the cessation of hostilities, or perhaps it still had some scores it wanted to settle.

For two more days, the *Dolphin* continued to take on wood (primarily mahogany) and water and completed its fitting out to put to sea and head back to Connecticut. But as it was preparing to leave on the sixth, its anchor became fouled, and a "great strain parted our cable." So it left Tortuga without its anchor but nonetheless homeward bound at last after a four-month cruise. It had managed to capture some prizes and loot a town and didn't lose a man in the process.

That stellar record changed, however, on the night of March 12, when a "man fell overboard off of the jibboom. We heaved around and hollered at him to keep his spirits up, but we could hear nothing to our great sorrow." A man overboard was not an unusual occurrence during the days of sailing ships. But it is somewhat ironic that after the travails of privateering, the only member of the ship's company was lost at sea rather than killed in action.

The *Dolphin* reached Tarpaulin Cove on Naushon Island on March 27, 1763. It then made its way back to Connecticut, and its cruise was deemed to be a success by all parties concerned. The colonies were still a decade away from the conflict that would change the course of history in North America and provide major impetus to the efforts of privateers yet to come. The actions of Captain Billings and his crew provided a template for the crews that would be so important in the upcoming struggle for freedom.

CAPTAIN JOHN UNDERHILL

There is a nineteenth-century wood engraving that shows an arrogant, fat, foppishly dressed Captain John Underhill ordering Dutch soldiers to vacate their fort called the House of Good Hope at the confluence of the Connecticut River and the Little (now the Park) River. Underhill is shown jerking his thumb in a "get the hell out of here" gesture that points to the sign that he hung on the fort's door. The sign reads, "I, John Underhill, do seize upon this house and land hitherto belonging as Dutch goods, claimed by the West India Company in Amsterdam…for the state of England." This seizure of the last Dutch structure on the Connecticut River is called "Underhill's single act as a privateer" by Gloria Merchant in her *Pirates of Colonial Newport*. That act effectively ended the Dutch presence as an economic power in the river valley. The soldiers and traders who had occupied the fort gathered up what possessions they could carry and sailed

downstream to New Amsterdam, never to return to the rich source of furs that made several fortunes for the merchants of Holland.

Other portraits of John Underhill show him to be not fat at all. He is shown as a thin, hatchet-faced Anglo-Saxon. Underhill is yet another of those seventeenth-century swashbucklers who seemed to be everywhere at once in the England/New England/New Amsterdam cauldron of political intrigue, cold and hot wars and the extermination of indigenous people. He fought both for and against the Dutch and the English at various times in his career. He was personally responsible for the coldblooded killing of hundreds of native people during the Pequot War and Kieft's War. He constantly found himself in and out of favor with colonial authorities. He was a feared warrior and an insightful writer who always managed to wreath his genocidal activities in a cloak of piety and righteousness.

Captain Underhill was descended from English nobility. Family members of his served in the retinue of Queen Elizabeth I. The family can trace its coat of arms all the way back to the thirteenth century. Underhill was born in the volatile Puritan incubator of Warwickshire in the late 1590s. His devoted mother decamped with him to Holland when he was a young boy. While there, he became a cadet in the guard of the Prince of Holland. In his twenties, he married a beautiful Dutch woman named Heylkin de Hooch. She Anglicized her name to Helena when she accompanied her husband across the Atlantic to New England in a party of religious dissidents and settlers that was led by John Winthrop.

His previous military experience stood him in good stead, and he was made a captain by the Massachusetts Bay Colony. Underhill performed ceremonial, civil and police-like duties as circumstances warranted. He was also elected to political office and served as a selectman and deputy of the court. At one point, he was ordered to arrest his rebellious friend Roger Williams for religious crimes and other seditious acts. Underhill was relieved to find that Williams had fled to parts unknown to escape from the Massachusetts colony's restrictive, religiously intolerant Puritanical governance. Williams later became instrumental in the founding of Rhode Island, with its much more liberal and accepting religious and political environment.

In 1634, Underhill returned to Europe to purchase a large quantity of gunpowder and other military supplies in anticipation of armed conflicts with the Indians, the Dutch and whoever England's enemy du jour might happen to be. Upon his return, he took on the role and responsibilities of a military engineer. His martial training and inclinations served him well as he insinuated himself into the highest echelons of the colony's military establishment. He

was instrumental in the development of a series of forts and fortifications to strengthen the colony's ability to withstand attacks should they come to pass. Underhill's ideas and opinions were sought after and respected in terms of short- and long-range plans to keep the colony safe from attack.

Captain Underhill joined with John Mason to mount a military expedition that led to the virtual extermination of the Pequot Indians on Block Island and Connecticut. Known as the Pequot War, it was a key event in the establishment of the Connecticut colony. He was commissioned as a captain by the General Court and was highly lauded and medaled for his military prowess in vanquishing the natives. But almost simultaneously, he was stripped of his commission and censured by the same political body for seditious writing. His crime was to write in support of a liberal Puritan minister who had been banished from the colony for offensive sermons.

Underhill returned briefly to England in 1638 and sought a military commission as a high-ranking officer in the Caribbean colonies, but he was unsuccessful and his request was denied as a result of the byzantine machinations that permeated the British military and political systems at the time. He was successful, however, in marketing a pamphlet entitled *Newes from America*. Underhill gained some local celebrity in the coffeehouses and salons of London as a result of his literary efforts. He was not quite so lionized upon his return to Massachusetts, however—he found himself banished from his adopted hometown, along with the seditious preacher he had championed. He was forced to sell his house and property in Boston and moved to the Exeter/Dover area. His reputation as a clever politician had preceded him, and he was soon elected governor of that region.

Captain Underhill was excommunicated from the church, only to be quickly reinstated, as the turbulent religious winds of the time began to blow in favor of the radical clergyman he supported. But even when he found himself back in the clergy's good graces, the political climate in Dover was such that he began to search around for a new place to hang his ostrich-plumed hat. Not only did he seek a new dwelling, but he also decided to disavow his allegiance to England and reaffirm his political commitment to Holland. The Massachusetts Bay government generously gave him the use of a pinnace to carry himself, his family and his property out of the colony, and he settled for a time in Stamford, Connecticut. He was promptly elected a deputy to the General Court in New Haven.

In 1644, he was placed in charge of a formidable military force that decimated a large Indian encampment near Greenwich. For this somewhat genocidal service, he was granted two parcels of land, one of which is now

called Bergen Island. The other is currently the site of Trinity Churchyard in Manhattan. He moved to New Amsterdam and took up residence on his Manhattan property. He must have been a consummate politician because as soon as he moved to the island, he was elected a member of the city's council and appointed a member of the group known as the Eight Men, which was charged with developing defensive and offensive strategies against the Indians.

He was made the sheriff of Flushing, but his regenerated alliance with the Dutch began to fray around the edges. He began to believe in a conspiracy theory popular at the time, that the Dutch were plotting with the Indians to drive the English from North America. Captain Underhill switched allegiance once again and hoisted the parliamentary colors atop the flagstaff on his New Amsterdam property. This blatant act did not go over particularly well with the Dutch governor, Peter Stuyvesant. The political shape-shifter further compounded that offense by writing a "seditious paper" addressed to the citizens of Long Island. Underhill was summarily thrown in jail for a brief period.

Upon his release, he realized that his adopted Dutch home was much too hot politically for comfort. He packed up his kit and caboodle once again and moved to Newport, Rhode Island. Shortly after arriving there, he was granted, essentially, a privateer's commission to attack the Dutch by water and land. This he succeeded in doing by capturing the aforementioned fort, the House of Good Hope, on the banks of the Connecticut River in Connecticut. His success in taking this Dutch stronghold was met with overall approval from the General Court of Hartford. Captain Underhill was duly awarded two prime parcels of land, including an island in the Connecticut River, in recognition of his efforts.

As an interesting historical footnote, the only casualties in the New England war between the English and the Dutch resulted from the activities of another Rhode Island–based privateer operating in Connecticut. Thomas Baxter was a bigamous scoundrel who vexed government officials throughout the New England colonies. At one point, he stole a bark belonging to Connecticut resident Samuel Mayo. A warrant was issued for his arrest, but he was a slippery sort and was able to avoid the sheriff and his shackles.

Baxter, the bold privateer, then made off with a valuable canoe that belonged to a prominent Connecticut magistrate. Apparently it is never a good idea to steal from a judge, and Baxter was promptly arrested and placed in prison. One of his crew was killed in an abortive attempt to free him from his cell. A Dutch officer was also killed in the ensuing skirmish.

The confluence of the Park and Connecticut Rivers today. The Park River was buried in the 1940s as a flood control measure. It is the site of the seventeenth-century Dutch fort the House of Good Hope. *Photo by Jeff Feldmann.*

From Baxter's point of view, it might have been a good thing that he found himself in the relative safety of prison for a while. As his case was being adjudicated, his wife in the colonies discovered that he also had a wife back in merry old England. Contemporary accounts list the colonial spouse as being none too pleased.

Captain Underhill moved his family permanently to Long Island, where he held a variety of law enforcement and governmental posts, including high constable and surveyor of customs. It is somewhat ironic that he became the chief advisor to the Matinecock Indian tribe and faithfully looked after their interests for years. The Matinecocks saw him as a bit of a savior given his role in the eradication of their bullying enemies, the Pequots. His was a life of shifting allegiances and contradictions. He served both the Dutch and the English. He was a decimator and a savior of indigenous people. His one act of privateering forever altered the economic and political realities of the Connecticut River Valley.

Captain John Stone

It is not without several ironies that an infamous, extremely unpopular pirate played a seminal role (albeit unwittingly and to his detriment) in the course of early colonial Connecticut history. Captain John Stone began his life as the privileged scion of a respectable family in England. But after his advantageous beginnings, his life took many downward directions. By the time he met his untimely demise, he was notable for being one of the most vilified and hated scoundrels in early New England's history. He started out in adult life as an honest, capable trader and developed a promising career arranging and facilitating commerce and travel between England and its new Atlantic colonies.

His family connections helped to position him in very promising business circumstances. He was a favored nephew of one of the first governors of colonial Virginia. Apparently, one or more members of the English nobility, as well as perhaps his uncle, granted him letters of marque that enabled him to ship cannons aboard his trading vessels to harass and capture ships that belonged to the ever-changing list of Britain's European enemies at the beginning of the seventeenth century. But like many an honest privateer before him, Captain John Stone crossed the fine and often ill-defined line that separated legitimate pillage from the shadier sort. Soon after they began, some of his privateering adventures were construed by the authorities to be piracy.

Not that Stone was any stranger to having authority figures look askance at him. At one point in his ignominious career, the blatant scoundrel was banished from the Massachusetts Bay Colony. He left the colony under a cloud so severe that his penalty would be death should he ever again be found on its land or waters. His response to the magistrates who pronounced his exile was an expletive-laced tirade that undoubtedly turned the air in the courtroom blue with its virulent and vituperative verbal violence. At one point, he was formally charged by colonial officials for committing acts of piracy. The unrepentant mariner was arraigned, and plans were made to return him to England to be tried. If he were found guilty, he would subsequently face death at the end of a hangman's rope. By a set of complicated legal contrivances indicative of the intricate machinations of the colonial judicial process, his charge was reduced to adultery, still a capital offence—and, in its own fashion, another form of piracy.

Captain Stone, not wishing to be hanged as an adulterer, snuck out of Massachusetts and headed for the colony of Connecticut. It was there that he met his historically less-than-heroic end. His murder ultimately set off a

wave of events that resonates throughout the geopolitical evolution of the Nutmeg State to this day. At a time when relations between the English colonists and the indigenous people they were displacing were deteriorating rapidly, Stone's death became the catalyst for the escalating enmity between the two groups.

Captain Stone really was the worst sort of apple. Historians often array a litany of negative adjectives to emphasize what an unpleasant fellow this malevolent mariner became throughout his seagoing career. "Horrible," "atrocious," "awful," "scurrilous" and "scandalous" are just some of the nicer things that history has to say about him. He is recorded as being a pirate, a privateer, a smuggler, a slaver, a drunkard, a lecher, an adulterer, a thief, a kidnapper, a murderer and, according to some accounts, a cannibal. (The cannibalism charge resulted from a shipwreck off the island of St. Christopher and may have been an example of "survival cannibalism," which seems to be a bit more morally acceptable than war-related or ritual cannibalism.)

If even half of the aspersions cast against his character were true, he would still be remembered as a major exemplar of bad behaviors. It was after his banishment from Massachusetts that Stone's karma finally caught up to him, and he became an integral part of Connecticut's early sociopolitical events. He made his way down the New England coast, bypassing Rhode Island and making Connecticut his homeport. Stone began "trading" with the indigenous groups who lived on the shores of Long Island Sound and the Connecticut River. Relations between the nascent English colony and the natives were already in a strained and tumultuous state, as the Indians sought to hold on to their territory while the European settlers craved resources and permanent control over the territory and its waterways.

It is my contention that "trading," for Captain Stone, was actually a form of piracy. Piracy is usually seen within the context of European or colonial corsairs capturing other European or colonial prizes. Of course, there was the Red Sea brand of piracy that saw Europeans preying on vessels from the Middle East and South Asia. Captain Kidd and his attacks on Muslim pilgrim ships would be an example. But history doesn't usually recognize seaborne depredations against Native Americans as piracy. Such incidences are considered to be "unfair trading practices" or the clever taking advantage of naïve people who had no real concept of private property and ownership. In reality, colonial seafarers often took what they wanted from the Indians with little or no thought to the consequences. Their superior firepower and the size of their vessels gave them an almost insurmountable advantage over

the wood and stone weapons and the rafts, birch-bark or dugout canoes of the natives. These practices surely seem to fit the definition of piracy.

It would seem that the unfairness of Stone's exchanges with the Pequots and the Nehantics, coupled with his arrogant personality, provided the impetus for the anger that ultimately cost the canoe-robbing cad his life. Captain Stone's last hours on earth were punctuated with several prodigious puncheons of strong rum, consumed convivially with the Indians who eventually killed him in a brutal and cruel manner. Encouraging and abetting indigenous people to become extremely intoxicated was one of the tried-and-true methods of getting the better of them in economic and social transactions. Stone's use of booze in this instance ultimately led to his undoing.

Captain Stone had anchored his vessel in the marshes that lay a short distance upstream from the mouth of the Connecticut River. He encountered some Pequots and Nehantics, and since they seemed friendly, he sent some of his crew ashore to hunt some game with some of them. He invited the other Indians and their sachem aboard his boat to see what possibilities existed for trade or plunder. In keeping with his bibulous nature, and his belief that he could outdrink any Indian who ever quaffed a quart of Killdevil, Stone caused the rum to run freely. The sachem and his doughty warriors, however, proved to be mighty tipplers themselves. They were wide awake and still had most of their wits about them when Stone decided that he needed a wee bit of a nap to ameliorate the effects of his afternoon's rumfest.

Unbeknownst to the passed-out pirate, the sailors of his hunting party had been dispatched by the tomahawks and arrows of his would-be trading partners. The balance of trade was about to tip precipitously in favor of the natives. While he slept, the sachem in charge of the Indian trading party bashed out his brains with a stout hickory war club. Thus the nefarious career of a notorious pirate came to a bloody and befitting end. The men who remained alive from Captain Stone's crew fought back bravely, but the Indians were eventually successful in completing their attack when they ignited all the gunpowder stored in the ship's magazine and blew the notorious ne'er-do-well's boat to kingdom come.

This violent and deadly encounter became one of the primary causes of the inevitable war between the English colonists and the bellicose Pequot Indians. Ironically, although Stone wasn't thought particularly well of when he was alive, his death became a rallying cry around which the colonists gathered their military might to solve the "Pequot problem" once and for all. Seeking to bring Captain Stone's killers to justice, the English

signed a duplicitous treaty with the Pequots that brought more colonists to Connecticut from Massachusetts.

Both the letter and the spirit of the treaty were ignored. Eventually, John Mason, John Oldham, Lion Gardiner and others raised an indomitable military force that all but exterminated the Pequot tribe and solidified English military and economic control of the Connecticut River and eastern Long Island Sound. Centuries after his violent (and some would say justly deserved) demise, Captain Stone continues to be excoriated as a scoundrel. But his historically important death proved to be a key event in creating the state of Connecticut that we know today.

JOHN OLDHAM

John Oldham was a bit of a brash and violent free spirit, at least for a Puritan. He crossed the Atlantic with one of the earliest companies of religious dissidents. Given his penchant for physicality, he might well have enjoyed smashing a few Catholic stained-glass windows and injuring some papist iconography before he departed from Europe. His reliance on fisticuffs to solve problems put him at odds with the colonist establishment shortly after he arrived in Massachusetts.

His contentious personality did not at all sit well with the military hero of Pilgrim lore, Miles Standish. Standish was charged with keeping the inhabitants of his Bay Colony settlement safe from attack by the hostile Indians whose land the Englishmen were usurping at a rapid rate. All the able-bodied men of the community were expected to do their part to keep the community secure from attack. One particularly chilly evening, Captain Standish called on John Oldham to rouse himself out of bed and take up his assigned duties guarding the village. Oldham may well have been under the influence of strong drink because his response to his commanding officer was to smash his fist into the surprised Standish's face. As if that weren't insubordination enough, he then held a knife to the astonished soldier's throat.

Shortly thereafter, the now highly unpopular Oldham gathered a few of his supporters and their possessions and trekked down to Connecticut, where the way the Congregational Church was governed was more to their liking. Connecticut was becoming a favored destination for English settlers who found the burgeoning population of Massachusetts to be somewhat crowded and cluttered. The fertile black soil of the floodplain in the Connecticut

River Valley promised to yield a variety of crops, and the river itself provided a conduit for goods and people that connected the colony to the wider world.

With the relatively peaceful relations with local groups of indigenous people, colonists from Massachusetts, such as Oldham and his crew, continued to migrate into Connecticut. They established territorial rights by buying and trading for land from local sachems and tribes. The settlement at Wethersfield started by John Oldham had a precarious start. His followers would not have survived the winter of 1635–36 without the kindness and direct aid of the Indians. Various sachems such as Sehat of Poquonnock, Armament of the Podunks and Sowheag and Sequassen sold large tracts of land to the settlers, including all of what is now Hartford and Windsor. Nassecowan, an English-loving sachem, was so taken by the Europeans that he gave them most of the eastern side of the river in the Windsor-Hartford area. Most of the lands were paid for by cloth, coats, axes, swords and wampum. But a treaty between the English and the bellicose Pequots was never fully realized. That hostile tribe and the English continued to quibble and quarrel with each other.

The vessel that upset this fragile equilibrium of quasi-peace belonged to none other than John Oldham, the Puritan renegade turned trader and captain. His settlement at Wethersfield survived its harsh beginnings. He sailed in the waters between Connecticut and Block Island with a crew of two English boys and two Indians to trade corn along the coast in the spring of 1636. In an act of indigenous piracy, his boat was set upon by a canoe full of Narragansett Indians from Block Island. Oldham was murdered as he stood at the helm hoping to repulse their attack. The Indians seized control of his boat and took the boys prisoner. They offloaded his cargo into their canoes in the hopes of turning a tidy profit.

As the transfer of goods was being made, Captain Gallop came upon the miscreants and recognized Oldham's vessel. Since Oldham was nowhere to be found, he deduced what had happened and went on the attack. He repeatedly rammed Oldham's boat, now in the possession of the Narragansetts, with his heavier craft. This caused several of the Indians to jump overboard and drown. He captured two of the pirates and tied them up, but fearing that they would untie each other and attack him, he heaved one of them, still bound, into the sea.

Gallop rammed the boat manned by the Indians again but failed to do much damage, so he began to shoot through its thin hull with musket fire. Even though two Indians still armed with swords remained below deck on what was once Oldham's pinnace, Gallop boarded it. He found the still

warm corpse of Captain Oldham, with its head split open and its arms and legs gashed as if they were in the process of being hacked off before his killers were interrupted in this grisly task. Thus ended what many believe to be the first sea battle fought in the New World.

Gallop and his crew consigned Oldham's remains to the sea as respectfully as possible given the circumstances. They brought the boat's sails and cargo aboard their vessel and attempted to tow it back to the mainland. But the wind and the seas rose, and Gallop was forced to cut it adrift. While the Narragansetts, not the Pequots, killed Oldham, it was rumored that the Pequots harbored his killers. A force was raised in Massachusetts to punish the Indians. It did some small damage to those living on Block Island and then proceeded to Lion Gardiner's fort at Saybrook. The events that would turn into the Pequot War had begun.

The Pequots had been unsuccessful in their attempts to overrun Lion Gardiner's Saybrook fort. They were much more successful when they attacked the village of Wethersfield, the town that the renegade Puritan Oldham had founded. The warlike Indians surprised the local inhabitants while they were out working in their onion fields—the soil of Wethersfield was particularly suited to the cultivation of onions. The Pequots killed several of the agriculturally inclined villagers and made off with two teenaged girls, the daughters of William Swain.

The marauders took their captives downriver, waving the clothing of their murdered victims like flags to taunt the defenders of the Saybrook fort. The girls were kept just out of cannon range and eventually taken to the Pequot stronghold of Mystic. They eventually gained their freedom after an extended period of captivity and were given an honored status among the English and Dutch alike. The Pequot War ended the trepidations of the tribe. John Oldham's boat and his village played important roles in bringing that conflict to a head.

GOVERNOR JONATHAN TRUMBULL

Jonathan Trumbull, the governor of Connecticut during the Revolutionary War, is rightly regarded as one of the most important figures responsible for the formation of our fledgling democracy. Trumbull was a graduate of Harvard College, and as a young man, his original plan was to go into the ministry to ensure that his altruistic impulses would be righteously focused.

The Governor Jonathan Trumbull House in Lebanon, Connecticut. *Photo by Scott Larkham.*

But his beloved brother's untimely death obligated the young graduate to assume an important role in the family business, which involved transatlantic shipping. Jonathan developed a network that instituted a system of trade directly with Great Britain that eliminated the necessity of intermediaries in Boston or New York. Said intermediaries were none too pleased, and he prospered for a time. But the redoubtable Trumbull suffered some serious economic reversals in the 1760s, and he teetered on bankruptcy. Fortunately, his business acumen was easily transferrable to the rough-and-tumble political arena. Known for his fairness and honesty, he rose steadily through the ranks of politicos to become governor of the colony when it was still a British possession.

Governor Trumbull played a key role in ensuring that Connecticut would adhere to the Patriot cause during the Revolutionary War. His unswerving commitment to democracy coupled with his administrative skills and his keen political acumen combined to make the state one of the most potent military and naval forces arrayed against Great Britain. Not only was he the governor of the colony before and after the war, but he also stood steadfastly alone as the only colonial governor to support the rebellion against the Crown. Trumbull had a close personal and

political relationship with fellow Patriot George Washington. He supplied the perpetually needy colonial armies with troops, munitions, supplies and money. Washington affectionately referred to him as "Brother Jonathan" and selected the Connecticut governor to be the paymaster for all American troops for the duration of the war. He was not able to fulfill his commitment to this obligation. He was forced to relinquish his paymaster duties when his mother became seriously ill and required his presence at her bedside.

Trumbull was not only a significant supporter of land-based military operations, but he also was instrumental in marshaling Connecticut's maritime industries into fighting units and privateer fleets that served to disrupt British naval and merchant shipping. The perpetually strategizing Trumbull worked to create a Connecticut state navy, and he was the originator of many letters of marque that rendered the state's blessing on the privateering efforts of its citizens under strict rules of engagement and prize taking. A typical Trumbull letter of marque would be similar to the one he issued to "Eli Rogers, Mariner, and Commander of a Vessel or Boat called the Gull belonging to Capt. Rueben Rose & Co. of said state":

You may by force of arms attack, subdue and take all ships and other vessels belonging to the Crown of Great Britain, or any of the subjects thereof, on the high seas or between the high and low water marks except the ships or vessels together with their cargo belonging to any inhabitant or inhabitants of Bermuda or such other ships or vessels bringing persons with intent to reside within the United States which you shall suffer to pass unmolested, the commander whereof permitting a peaceable search & giving satisfactory information of the contents of the lading and destination of their voyages.

You shall bring such ships & vessels as you shall take with their guns, rigging, tackle, apparel, furniture and lading to some convenient port in this state, that proceedings may thereupon be had in due time before the courts which are or shall be then appointed to hear and determine causes Civil and maritime.

You or one of your Chief officers shall bring or send the Master and pilot and one or more principal person or persons of the company of every ship or vessel by you taken as soon after the capture as may be to the judge or judges of such court aforesaid to be examined upon Oath and make answer to the interrogations which may be propounded touching the interest or property of the ship or vessel and her lading and at the examination you shall deliver or cause to be delivered to judge or judges all Papers, Sea Briefs,

Charter Parties, Bills of Lading, Packets, Letters and other Documents and writings found on board, providing the said papers by the affidavit of yourself or some other person present at the capture, to be produced as they were received without a fraud, addition, subduction or embezzlement.

You shall keep and preserve every ship or vessel and cargo by you taken until they by sentence of a court properly authorized be adjudged lawful prize or acquitted, not selling, spoiling, wasting or diminishing the same nor breaking the bulk thereof not suffering any such thing to be done.

You shall by all convenient opportunities send to me written accounts of the captures, copies of your journal from time to time and intelligence of what may occur with the number and names of the captives and whatever you shall discover concerning the designs of the enemy and the destination, motions and operations of their Fleets and Armies.

You shall observe all such further instructions as shall be given you hereafter by me in the premises where you shall have notice thereof. You shall not by yourself or Crew practice any illicit trade with the enemy on Long Island but you shall take care to detect all illicit trade to said island or any other place within the enemy lines or dominions and bring to condign punishment all such person or persons as you shall discover to be concerned in or carrying on any illicit trade or traitorous practice with the enemy according to the Law in such case made and provided and if you shall do anything contrary to these instructions or to others hereafter to be given or willingly suffer such things to be done, you shall not only forfeit you Commission and be liable to an action for breach of the conditions of your Bond but be responsible to the party grieved for damages sustained by such malversations.

You shall keep your Journal from the time of your setting forth on your cruise and preserve every material resource and making your proceedings known to me at the end of forty days, or to Brigadier General Ward at Guilford. Dated at Lebanon the 1ˢᵗ of May, AD 1781, Jonathan Trumbull.

Trumbull's explicit and detailed instructions to Captain Rogers bore fruit for the economy of the Connecticut colony. Teaming up with the privateers the *Rattlesnake* and the *Revenue*, the *Gull* took part in the capture of three sizable British ships. These were the *John*, the *Lively* and the *Mayflower*, for an overall haul of almost 250 tons of enemy shipping. By the end of the war, Jonathan Trumbull had affixed his signature to well over two dozen letters of marque. Some of the most well-known Connecticut privateers that sailed under his aegis include the *Abigail*, the *Betsey*, the *Enterprise*, the *Experiment*, the

Fair Trader, the *Hero*, the *Humbird*, the *Jason*, the *Lash*, the *Lucy*, the *Mentor*, the *Nancy*, the *Ranger*, the *Samuel*, the *Snake* and the *Washington*.

One of the ways in which Trumbull was honored for his service to his young, beloved country was to have several sailing ships named after him. Fittingly, these included a privateer and at least two naval vessels. The splendid privateer, christened at its launch with the name *Governor Trumbull*, was built in Norwich at the Willet's shipyard, not far from Trumbull's home in Lebanon, Connecticut. It was owned by Howland and Coit, the firm that sent several Connecticut privateers to sea. It was commissioned in November 1778 and put under the command of Captain Henry Billings. A formidable vessel, it shipped a crew of 150 men and carried twenty cannons. Before the *Governor Trumbull* began its privateering career, it assisted in the salvage operations that secured what remained of value from the wreckage of the British transport ship the *Marquis of Rockingham*. That unfortunate enemy ship was smashed up on the shores of Gardiners Island in December 1778. Only 5 members of the *Rockingham*'s crew of 22 survived the wreck—most of the others froze to death on the ice-covered beaches and inlets of Gardiners Island.

Captain Billings, the scion of an old Connecticut seagoing family, then sailed the brand-new privateer to the West Indies. There the *Governor*

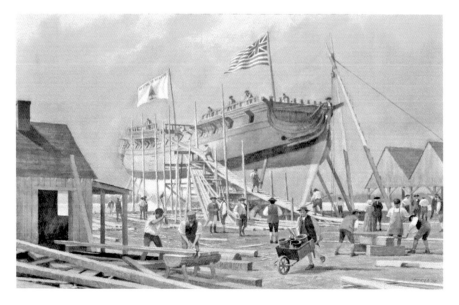

The Connecticut ship *Governor Trumbull* under construction. *Courtesy of the Connecticut River Museum.*

Trumbull took on an aggressive role in the invasion of the island of Tobago. The ship's company took several prisoners and did not suffer any serious casualties. Its resourceful crew helped build a small redoubt at Man of War Bay to reinforce a somewhat dubious colonial claim to the island and generally harass and impede the British and their allies. They armed the small fortress with several swivel guns and at least two cannons. The rambunctious Americans then raided some British sugar plantations, which incited the enemy to launch a counterattack on their small fort. The Yankee swivel guns did some damage to the officers leading the raiding party, and the British quickly withdrew in defeat. A second attack on the fort was more successful, and the Americans were forced to retreat on the *Governor Trumbull*. They weighed their anchor as quickly as possible and made a hasty exit out of the harbor. The Yankee privateer managed to elude the English ships sent to chase it down and sink it.

Its luck, however, ran out on March 5, 1779, when it was run down by two British frigates, each named for mythological goddesses, the *Ariadne* and the *Venus*. It was the *Venus*, with its flame-spitting twenty-six-gun broadsides, that eventually caused the *Governor Trumbull* to strike its colors and surrender after a valiant fight. It was taken to Barbados, where it was libeled and eventually renamed the *Tobago* (not without some irony) and put into service as a British vessel of war.

There were two other Continental naval vessels that also bore the name of the Connecticut governor. The first was a small galley that saw service on strategically important Lake Champlain. This boat served as part of a makeshift fleet commanded by none other than Norwich, Connecticut native Benedict Arnold before his traitorous switching of sides at the height of the Revolutionary War. This *Trumbull* managed to escape being a victim of the carnage at the Battle of Valcour Island but was ultimately captured by the British and destroyed.

The next *Trumbull* was built on the banks of the Connecticut River at Chatham, Connecticut. It was one of a fleet of frigates ordered by the young colonies' navy (although, at the time, it was often difficult to distinguish a Connecticut navy ship from a privateer; they were similar in both form and function). This river-built vessel's considerable size and draft, however, made it problematic as to whether it would ever be able to get over the sandbars that guard the mouth of the mighty Connecticut. Until some means could be figured out as to how to float it over the shoals and out into Long Island Sound, it was very vulnerable to attack by land or sea. Fortunately for the young ship, that attack never came. It finally

floated free in 1779, when the innovative, creative mind of Captain Elisha Hinman suggested that several water casks be lashed along either side of its hull and pumped dry. This clever stratagem provided the big boat with just enough buoyancy to clear the bar at high tide and make its way into Long Island Sound.

It was then put under the command of Captain James Nicholson and proceeded to New London, where it was fitted out for sea under the supervision of Nathaniel Shaw. The *Trumbull* soon was engaged in a fight to the death with the English privateer *Watt*. Both vessels blasted broadside after broadside into each other's hulls. The air hung thick with smoke, and their decks ran slick with sailors' blood. Banging alongside each other, their riggings became entangled, and dangerous fires broke out on both ships. Each vessel was a badly damaged wreck unable to sustain a fight. At that point, they broke off the engagement and limped back to friendly ports with no clear-cut winner discernable from the fray.

A scarcity of resources, not uncommon during the Revolution, kept the *Trumbull* tied up to a dock in Philadelphia for an extended period of time. Seemingly eager to see more action, it finally put to sea off the Delaware Capes in August 1781. After losing its foretopmast and its main topgallant mast in a pounding gale, it was set upon by two British warships that, ironically, had been American privateers before their capture. Without much of its rigging and lacking the ability to maneuver, many of Nicholson's crew did not have much of a will to fight. Three-fourths of them remained below decks in a cowardly fashion. The few sailors with a fighting spirit who remained put forth a valiant defensive effort, but it was in vain. A virtual wreck, the *Governor Trumbull* was taken in tow by the British but was too far gone to see further service to either side.

Exhausted by his years as a wartime governor and out of favor in Connecticut political circles, Jonathan Trumbull left the public arena. He retired to his home in Lebanon, Connecticut, and spent his later years in the study of theology. The governor's profound military, naval and political efforts on behalf of his young country still stand today as a testament to patriotism and bravery. A Connecticut town is named after him, as are many streets throughout the state. His contributions to the state's successes at sea will be remembered when the deeds of brave sailors are spoken of reverently or raucously in the Nutmeg State.

Long Island Sound's Whaleboats

Separating the Connecticut coastline from Long Island by only a few miles, the relatively placid (compared to the open ocean) waters of Long Island Sound proved to be an ideal environment in which privateers could use small whaleboats to overwhelm and capture much larger prizes. Much as modern-day pirates use small, fast, seaworthy boats to board and take the crews of very large ships hostage, the swift, highly maneuverable whaleboats could overpower crews much larger and better armed through sheer bravery, ferocity, foolhardiness and valor. Connecticut was primarily the domain of Patriots, but for much of the Revolutionary War, Long Island was firmly in the control of the British. Many Tories left Connecticut to live in the relative safety of Long Island and vice versa; many Americans sympathetic to the Patriot cause crossed the Sound to live among friendly fellow freedom fighters in Connecticut.

Neither shore could provide ironclad guarantees of safety to adherents of either side, however. The versatility and shallow drafts of the limber whaleboats allowed their crews to land in the inlets and coves along both sides of the Sound to pillage the houses, farms and businesses of their enemies. Since Long Island was a major source of supplies and forage such as wood and hay to the large British armies centered in New York, Connecticut raiders would often attack, steal or burn large quantities of material that could be useful for the English war effort. Conversely, British forces would cross the Sound to raid, pillage, kill and, as did the Americans, take hostages.

The basic design of whaleboats harkens back to the days of the Vikings, who constructed fast, shallow-draft vessels that proved ideal for both raiding and commercial purposes. As will be seen, the whaleboatmen of Long Island Sound used them for both purposes, sometimes illicitly. Whaleboats were double-ended, usually between twenty-five and thirty-five feet in length and were propelled by five to ten oarsmen, with a boat steerer in the stern to guide the vessel with a steering oar or rudder. Their speed, seaworthiness and superior handling qualities made them the ideal means of pursuing and harpooning whales. They were light enough to be rowed long distances and stable enough to stay upright during a "Nantucket sleigh ride," when they were towed behind an angry, injured, harpooned whale. They often shipped a mainsail and sometimes a jib. A centerboard was usually added to provide additional stability.

The whaleboats that served as Connecticut privateers during the Revolutionary War, in many cases, mounted small cannons known as swivel guns on their bows. But it was often the sheer terror that the brutal fighting

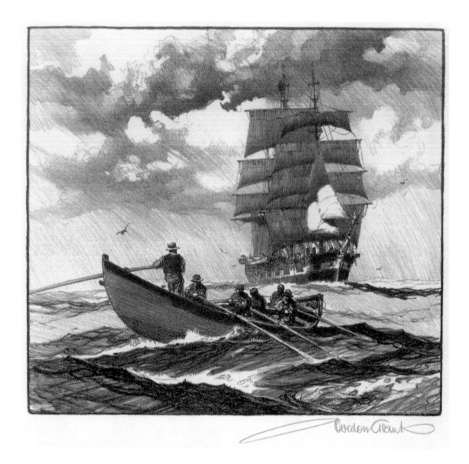

Modeled after Viking longships, light, shallow-draft whaleboats made for ideal privateering vessels in Long Island Sound. ©*Mystic Seaport.*

skills of their crews evoked that caused enemies to surrender. It was often prudent to admit defeat rather than face the pistols, pikes, cutlasses, muskets, daggers and fists of their formidable foes. Since the whaleboats didn't require a lot of men to man them, the captain could usually persuade a few of his cronies down at the local tavern to go a pirating with him after springing for a few tankards of rum. Fighting and plunder weren't the only uses that whaleboats were put to during the Revolution. They often served as conduits for spies and carried vital intelligence across the Sound for both sides. They also were known to occasionally transport contraband, and as the war wound down, they became notorious for trading with the enemy.

Many privateer whaleboats operated legitimately with letters of marque and commissions from state or federal authorities, but many did not. Some

Whaleboats used grappling hooks to attach their boats to their victims' vessels. *Photo by Ray Guasp, courtesy of the Connecticut River Museum.*

posted bonds as required by law, but some did not. A few of the boats carried militia officers and troops, and there were often mixed crews of civilians and soldiers. The fluidity of the times proved to paint a broad canvas of combatants that often defied formal classifications as privateer, pirate, bonafide military or naval officer, sailor or soldier. Their combined exploits, however, provided a panoply of adventure, skullduggery, derring-do, intrigue and bellicosity.

Whaleboats operated in the Sound from New London all the way to the New York border, but its western end was particularly suited to their activities because it is at its narrowest points there and because so many Tories and Patriots lived on its shores. Stamford, Connecticut, with its strong harbor defenses, was one of their most popular ports, but New Haven, Fairfield, Guilford, Branford and Saybrook all saw their share of freebooters and privateers, legitimate and otherwise, row out of and into their harbors. Some of the names associated with whaleboat activities still resonate in the lore of coastal Connecticut.

For example, Stamford was the homeport of what is known as its "Three-Gun Armada." Under the command of the intrepid Ebenezer Jones, his whaleboats—named the *Saratoga*, the *Viper* and the *Rattlesnake*—played important roles in defending Stamford harbor; all had remarkable records

of capturing much larger British vessels and their crews. The *Rattlesnake* and its sister vessels were responsible for taking thirty-seven prizes from January 1781 to March 1783, quite an accomplishment for relatively small vessels in a brief period. Jones operated as a legitimate privateer with a government-certified letter of marque and a $20,000 bond issued by two Stamford businessmen.

Ebenezer Jones's victims were primarily schooners. His captured cargoes included a wide variety of items, from general merchandise to wood, hay, onions, sheep, textiles and canoes. There is a story that still circulates of Ebenezer Jones using subterfuge to capture a large British warship. According to the tale, he was cruising off the North Shore of Long Island on a very foggy morning when he came upon the English ship. He and a few of his crew clambered aboard, and Jones pretended to be a British naval inspector and began to berate the surprised Royal Navy captain for allowing another vessel to get so close to the king's ship as to be able to board it. After he evaluated the situation aboard, he stamped his foot loudly on the deck, which gave the signal to his other boats to board the warship and overpower its astonished crew.

Not all of the privateering action on the Sound was carried out as lawfully as Jones managed to do it. Connecticut's governor, Jonathan Trumbull, had his hands full trying to sort out what was legally in-bounds and what wasn't when it came to cross-Sound forays. When refugees from the Tories would go back to Long Island to retrieve possessions, they weren't averse to taking back some things that belonged to Loyalists. Likewise, Tories would land in Connecticut under the guise of taking what was lawfully theirs and also abscond with things that weren't. The state government eventually had to assemble a committee to try and sort out the claims and counterclaims of the aggrieved.

Caleb Brewster recounted a midnight raid by two Connecticut whaleboats. Their crews descended on the house of a Captain Miller and his son, Andrew. The marauders seized the captain's weapons, and when his son tried to escape by jumping out a window, they shot him dead. Brewster went on to list other examples of bad behavior on the part of Connecticut raiders: houses ransacked, residents tortured, highway robbery and worse. The British governor complained to Trumbull, who said that for the most part his citizens were on the up and up, but he did admit that there might be one or two bad apples whose intentions weren't all that noble. Eventually, he was forced to agree that the depredations were completely out of control, and he abolished the privateering commissions for the whaleboaters.

A swivel gun of the type used on whaleboats. It is incorrectly mounted here as a fieldpiece. *Photo by Ray Guasp, courtesy of the Connecticut River Museum.*

The governor's edict didn't do much to end the vicious enmity that festered into open warfare across the Sound. The egregious raids continued unabated. The British burned Fairfield, took hostages and generally raised hell when they could. The Patriots responded in kind. An angry, frustrated Governor Trumbull called off his privateering commissions for a second time, but still the ferocious activities continued on the part of both sides. Trumbull then directed local government officials to widely disseminate his edicts, so that no one could plead ignorance of the law. Finally, he ordered the militia to put a stop to the raids by confiscating the offending boats and their equipment.

The aforementioned Caleb Brewster was an interesting character who played an important role in what became known as "the Boat Fight." He was a native of Setauket, Long Island, but was an ardent American Patriot. He was an important spy in the chain of intelligence vital to the cause, a vital link in a chain of secret information that originated with undercover intelligence agents in New York City. Brewster would cross the Sound at night in his whaleboat and convey the valuable knowledge to one Major Tallmadge, who then passed it along to General George Washington.

An adventurous lad, Brewster began his whaleboat career in a boat employed in the actual pursuit of whales on a voyage to Greenland in 1756. He then became a merchant seaman, but when he learned that the colonies were in rebellion, he returned to North America and immediately enlisted in the Patriot cause. He began as an artilleryman, but his wits and cunning soon made him an indispensable intelligence agent. He also served as a hands-on combatant. He and some other whaleboatmen planned an attack on British troops who had converted a Long Island church into a fort. Their ambitious attempt was thwarted when Hessian reinforcements arrived in overwhelming numbers, and the Patriots had to scurry back to their boats and row hastily across the Sound to Connecticut.

He was part of other more successful forays, as well. At one point, he accompanied his spy-handler, Major Tallmadge, in a successful attack on a British fort called St. George on Mastic, Long Island. They took several prisoners and managed to burn a huge haystack that the English had accumulated to feed their New York army's horses. He was in command of a small flotilla of whaleboats that engaged in "the Boat Fight," a vicious mano-a-mano struggle between equally armed and manned boats. Necks were slashed ear to ear, skulls were bashed in and bones were broken. Brewster suffered a severe shoulder wound from a musket ball and was laid up for a long time. He recovered to fight in whaleboats yet again and was instrumental in the capture of the armed British vessel the *Fox*.

Another hero of the Battle of Fort George was a Newington, Connecticut native named Sergeant Elijah Churchill. A member of the family who eventually produced Winston, Sergeant Churchill proved to be a resourceful leader and skilled whaleboat raider. He was the leader of one of the three groups into which Major Tallmadge divided his force. The fort was an impressive military installation. It covered several acres of land and was protected by a deep moat. Churchill was instrumental in coordinating the attack that destroyed the fort, burned several British vessels and captured more than three hundred prisoners. The aforementioned burning of three hundred tons of hay severely limited the British army's ability to move cavalry, artillery and supplies by horses, which were badly undernourished without forage and fodder.

On October 1781, Sergeant Churchill once again demonstrated his whaleboating and martial skills. He was in charge of a fleet of whaleboats manned by one hundred dragoons and infantrymen from the Fifth Regiment of the Continental line. They rowed out from Westport, Connecticut, under cover of darkness and surprised the defenders of Fort Slongo near

Northport, Long Island. Churchill and his men were able to capture twenty-one prisoners and destroy a large quantity of military supplies, as well as several tons of all-important hay. They rowed triumphant back to the Connecticut shore with their abashed prisoners in tow.

For his valorous service, Sergeant Churchill was selected by General George Washington to receive the Badge of Military Merit. Churchill is one of only three known recipients. It would be equivalent to the Congressional Medal of Honor today. General Washington's commendation praises "Segeant Elijah Churchill of the 2nd Regiment of Light Dragoons, in the several enterprises against Fort George and Fort Slongo on Long Island, [he] acted in a very conspicuous and singularly meritorious part; that at the head of each body of attack he not only acquitted himself with great gallantry, firmness and address, but the surprise in one instance and the success of the attack in the other proceeded in a considerable degree from his conduct and management."

The aptly named Simeon Crossman is another whaleboat captain whose exploits are remembered, albeit in a not-so-favorable light. Crossman led a raid in August 1781 on the home of William Sweezy, who, ironically, was an American Patriot. It is an example of the privateering ethic run amok that some of the raiders no longer displayed loyalty to either side but had, essentially, turned fully into pirates, pillaging and robbing whoever was unfortunate enough to fall into their path. Crossman's brother, Asel, was in his crew, as was a brigand named Jacob Arnold and other unidentified men. This crew terrorized Sweezy, ransacked his house, abused his mother and generally behaved poorly. The irony was twice as thick, as the victim thought the raiders were Tories who were punishing him for being a Patriot.

The pirates stole his money, took his pen knives and appropriated his Latin dictionary and a book by Aristotle. They took his clothes, his saddle, his buckles and his tobacco box. His guns and ammunition were taken away, as was most of his food, sugar and tea. After terrorizing his aged mother, they cursed, threatened and tied Sweezy up. Only after they were convinced that there was nothing more of any real value left did they take their leave of the thoroughly shaken man and his badly frightened mother. Sweezy eventually sued Crossman, but it is not known if his suit was successful or not.

On the other hand, some of the whaleboat warriors of the Sound were honorable men. For example, the career of Return Jonathan Meigs Sr. shows him to be a paragon of bravery and resourcefulness. He was originally from Middletown, Connecticut, and started out as a merchant. The turbulent environment of the eighteenth century led him to a military career. He fought in the Battle of Lexington and became a major in the Second Connecticut

Regiment in the Continental army. The resourceful Meigs kept a journal with ink that he cleverly compounded by mixing gunpowder and water. He took part in the assault on Quebec and was captured and later paroled by the British. Upon his release, he returned to Connecticut.

He was promoted to lieutenant colonel and became the key figure in what has become known as the Meigs Raid. He led 220 men, most of whom were American Patriots displaced from Long Island to Connecticut. His fleet of thirteen whaleboats crossed Long Island Sound in the dark of a new moon night and attacked the fleet of British boats tied up to Long Wharf in Sag Harbor, Long Island, in May 1777. The element of surprise and excellent leadership on the part of Meigs resulted in twelve enemy vessels burned and 90 British seamen and officers taken prisoner. The Americans did not lose a single man. Meigs was awarded a ceremonial sword for his bravery and was promoted to full colonel by Governor Jonathan Trumbull. He later held important military and government posts in Ohio and Tennessee.

The career of whaleboating privateer Ebenezer Dayton, however, was marked by somewhat less valor and much more ambiguity. Dayton was a Long Island native who fled to Connecticut when the British began looting and raiding Patriot homes on the island. He was a traveling peddler by trade but joined the minutemen and proved to be a good soldier. Returning to Connecticut, he joined up with several displaced Long Islanders in the whaleboat raiding business. He was successful enough to acquire a small schooner, the *Suffolk*, and was commissioned as a privateer by Governor Trumbull. He took three British sloops as prizes—the *Dispatch*, the *Polly* and the *Jane*, as well as a smaller vessel, the *Lively*—all loaded with food for British troops in New York. These were duly libeled, and Dayton realized a tidy profit.

He then teamed his sloop up with four whaleboats out of New London and cruised into the Great South Bay. He captured a British brig loaded with tobacco but was then captured by a British man-of-war. He either escaped or was paroled and returned to Connecticut and his whaleboat raiding ways, continuing to attack houses on Long Island and harass English shipping. He was a palpable thorn in the sides of many Tories. His abrasive, bragging, self-promoting personality did not make him very popular with people on either side of the Sound.

A young British officer decided to put an end to Dayton's depredations. He recruited a group of Long Island ne'er-do-wells, and on March 14, 1780, they rowed across Long Island Sound and proceeded to smash their way into his house, bent on revenge and rapine. Dayton, however, was in

Massachusetts at the time, so they contented themselves with terrorizing his wife and children while stripping the place bare. They made off with a hefty haul valued at more than £400. As they made their escape, they were recognized by a local lad, so the marauders tied him up, declared him to be prisoner, tossed him into a whaleboat and took him back across the Sound.

Dayton's wife, in the meantime, freed herself from her bonds and alerted the community, members of which set off across the Sound in pursuit of her tormentors. The Connecticut Patriots found the miscreants, freed their prisoner, recaptured Dayton's goods and took the officer who planned the raid as their prisoner. He was put in jail but later escaped and fled to Canada. Dayton was often thought to be a smuggler who willingly traded with the British, and many accused him of raiding Patriot homes as well as Tory.

His popularity hit an all-time low after he returned to his itinerant peddling activities and was thought to have brought a measles epidemic to the town of East Hampton, Connecticut. He was ducked in the town pond and had other violence done to him. He finally made a hasty, ignominious exit out of town and vowed never to return, which was fine with the townsfolk. He was extremely disliked by the citizens of Connecticut and finally disappeared after a swim in the Housatonic River. His clothes were found, but his body never was. It was commonly believed that he faked his own death and assumed a new identity elsewhere with his ill-gotten gains. Dayton epitomizes the disintegration of whaleboat privateering on the Sound into collaboration with the enemy and smuggling. As the war wound down to the inevitable British defeat, the profit motive began to trump valor and patriotism.

THE OLIVER CROMWELL

This ship was given its name in honor of the brash English Revolutionary whose followers fled Great Britain and became instrumental in establishing the Connecticut colony. Destined to fight in yet other revolutions, the *Oliver Cromwell* was built in 1776 per the order of the Connecticut state government at the Essex shipyard of Uriah Hayden. This was the same yard that had built the Connecticut privateer brig *Defense* the year before. After the *Oliver Cromwell* was launched, it was carefully piloted down the Connecticut River estuary by James Harris. At the time of its maiden voyage, it was the largest vessel ever to cross over the shallow shoals at the mouth of the river. It carried twenty guns and was initially placed under the command of Captain

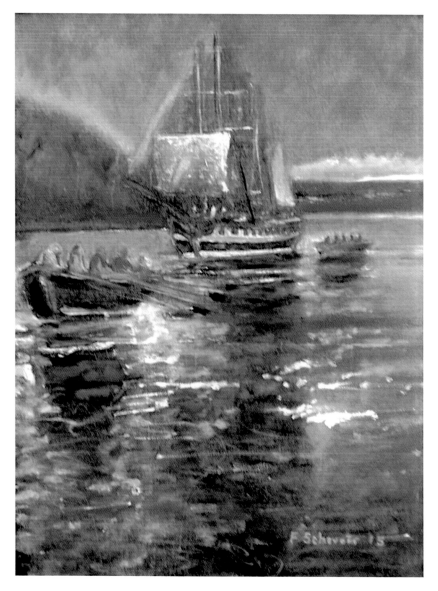

Maritime Impressionist Frederick Schavoir painted the *Oliver Cromwell* making its way down the Connecticut River on its maiden voyage. *Photo by author.*

William Coit. The Coit family owned and operated many Connecticut privateers. After successfully exiting the tricky waters at the river's mouth, it made its way to the noted privateering port of New London to fit out and, hopefully, fill out its crew list.

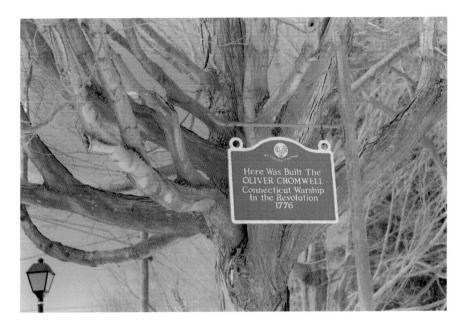

This sign marks the place where the *Oliver Cromwell* was built. *Photo by Ray Guasp.*

It was compelled to stay at the dock in New London much longer than initially anticipated. The British Royal Navy had tightened its grip on its blockade of the town, the harbor and the waters surrounding it. The *Oliver Cromwell* also experienced personnel problems among several of its officers. Both of these circumstances caused delays in its eventual departure as a fighting vessel. The crew grew a bit impatient for action and looked for ways to amuse itself both aboard ship and in the grogshops and other establishments in town.

While the crew whiled away its time in New London, the captain of one of its sister privateers celebrated his marriage with all due nautical protocol. As a proper salute, the officers of the *Cromwell* ordered that a cannon be fired in honor of their comrade in arms' wedding day. A bored, mischief-minded crew member stuffed a hand grenade down the barrel of the gun, and the resulting blast "whistled through the town the like was never known." Outraged citizens, who didn't think that explosive devices detonated in their community were funny, demanded that the perpetrator be punished. The now repentant miscreant was duly arrested and put in irons for a time. When the ship was ready for sea, however, he was released and allowed to resume his duties.

This combustible caper was an almost welcome diversion from the bureaucratic wrangling that delayed the maiden voyage of the *Cromwell*. The

ship's surgeon resigned under a cloud of animosity and had to be replaced. There was confusion when it came to entering the crew onto the ship's registry. There was an ongoing general dissatisfaction among the officers, several of whom resigned or were dismissed and had to be replaced. Pay was slow in coming, if it showed up at all. Several officers, eager for action and promotion, left to take command of their own privateers. The crew was surly to the point of being mutinous. Munitions and supplies were hard to come by and very expensive. In all, it was a difficult time for the ship's company to be stuck in port when adventure and prizes beckoned on the high seas.

One of the results of this general dissatisfaction was that Captain Coit, the captain with extensive experience and family connections, was summarily relieved of his commission and duties, and the *Cromwell* was placed under the command of Captain Seth Harding. Harding had previously held command of the Connecticut privateer *Defense* but relinquished it to Samuel Smedley because he had fallen quite ill. Having sufficiently recovered, however, Harding shuffled the makeup of his officers and enlisted a new crew for the *Cromwell*. On April 22, 1777, the ship was inspected by the governor and his retinue and deemed fit for sea duty. Before sailing, however, the captain of marines, yet another surgeon and two lieutenants were dismissed under a cloud and replaced.

The Connecticut vessel was finally able to put to sea on May 21 with a crew of 102 men. It then put into Dartmouth, Massachusetts, where Captain Harding conducted a vigorous recruiting campaign and finally realized a full ship's complement of 150 sailors. He finally put to sea in search of prizes and was almost immediately rewarded with the capture of the British brig *Honour*, which he took back to Dartmouth and libeled for more than £10,000 sterling. Very quickly thereafter, he overcame and captured the *Weymouth* and took it to Boston. He then captured the ship *Restoration* and put it in the charge of a brave young midshipman named Sherman Lewis. As was often the case, prizes were vulnerable to recapture by the enemy, and the *Restoration* was taken from Lewis by the British ship *Ambuscade* and brought into Halifax, Nova Scotia. This turnover of prizes was an interesting but confusing aspect of the privateering efforts of both the Americans and the British.

The English prisoners taken from the *Weymouth* were escorted overland by a seaman from the *Cromwell* named Azariah Hilliard. He successfully shepherded his charges to New London, where it was arranged for them to be transported by water to New York, where they would be duly exchanged for their American counterparts who were held by the British. As prisoners were

being sailed down Long Island Sound, however, they rebelled, overpowered their captors and ran the commandeered boat into a beach on Long Island, where they all escaped and lit out for parts unknown. The officers of the *Weymouth* and *Honour*, however, were sent to Lebanon, Connecticut, under the watchful eye of midshipman Reed and were duly exchanged for Americans.

Captain Harding's recurring poor health problems continued to plague him, and he was eventually compelled to give up command of the *Cromwell*. He was replaced by Timothy Parker, who took it into Boston for a quick refit to make it ready for another cruise in pursuit of prizes. It was decided that he would cruise in company with Captain Smedley's ship *Defense*; however, the *Defense* was undergoing some reconstruction, and they weren't able to put to sea in tandem until February 1778. Meanwhile, Captain Harding once again recovered from his prolonged illness and was this time put in command of the frigate *Confederacy*, being built on the Thames River in Norwich, Connecticut.

While cruising in consort with the *Defense*, the unfortunate crews of both ships were stricken by an outbreak of smallpox. Even under these diminished circumstances, the two colonial cruisers were able to capture the British privateers the *Admiral Keppel* and the *Cyrus* off the Caribbean island of St. Kitts. Both of these English vessels carried eighteen guns and were heavily laden with cargo. They were particularly rich prizes and fetched a considerable sum for the state and its sailors when they were brought to Boston to be libeled and auctioned.

Among the prisoners taken from those ships was the British aristocrat the Honorable Henry Shirley, along with his family and entourage. They were on their way to the island of Jamaica, where Henry was to assume the office of governor. After much bureaucratic back and forth, Governor Jonathan Trumbull of Connecticut allowed him to proceed to Jamaica to take up his duties. He was compelled to travel at his own expense, however, and agreed to facilitate an equal exchange of American prisoners—which, in fact, he did.

Heading back up the eastern seaboard of the fledgling United States, it put into South Carolina. The *Cromwell* then narrowly escaped complete destruction when it was hit by a hurricane on August 24, 1778, after it had left Charleston, South Carolina, on its way to France with a cargo of indigo. (Privateers often doubled as cargo vessels.) Badly damaged, it was in no condition to cross the Atlantic and barely able to make sail, yet it made its way under a jury-rig back to New London for a complete overhaul. It was finally able to reach the Connecticut port and underwent a badly needed refitting.

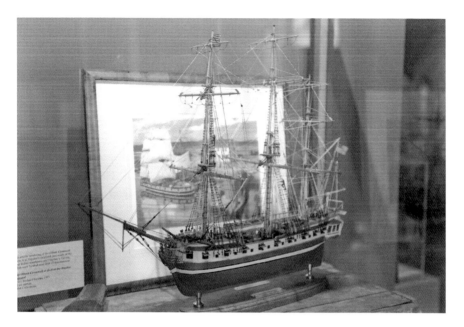

A model of the *Oliver Cromwell* as it looked during the Revolutionary War. *Photo by Ray Guasp, courtesy of the Connecticut River Museum.*

After its reconditioning, the *Cromwell* made a quick foray in search of prizes in October 1778. Hoping to add to its tally of captures before winter set in, it successfully took the brig *Medway* and sent it into Hyannis as a prize, where it brought almost £4,000 at auction. The coming of cold weather sent the *Cromwell* back to its homeport of New London, where it spent the winter. A new crew was recruited, and arrangements were made for the ship to share dividends commensurate with the compensation granted to other privateers. It completed its preparations and put to sea in April 1779.

The following month, it returned in triumph to New London with four fat British prizes. The schooners *Hazard*, *St. George* and *Dove* and the frigate tender *York* were libeled in the Connecticut courts for tidy sums. Eager to strike while the iron was hot, the *Cromwell* immediately put to sea again in search of more prizes, but its good fortune as a successful American sea raider was about to come to an end.

The *Cromwell* was cruising south of Sandy Hook on June 6, 1779, when it was beset by three British ships and a brig. The English vessels were fast and agile, and the *Cromwell's* Captain Parker and his men were clearly overmatched and outgunned. They mounted a spirited defense, but with no hope of victory, they were forced to strike their colors and surrender.

Captain Parker and his crew members were taken as prisoners to New York, where they were eventually exchanged in the gentlemanly fashion of the day. The British (with a tip of the hat to irony) renamed the *Cromwell* the *Restoration* and were quite pleased to have its twenty guns in their arsenal.

Captain Parker had been captured and exchanged before, when he served on the schooner *Spy*. After he was freed from this most recent incarceration in New York, he returned to privateering as commander of the ship *Scourge*. It was about the same size as the *Cromwell*, with twenty guns and a crew of 150. He later was skipper of the much smaller sloop *Prudence*, out of Norwich, Connecticut, and briefly was the captain of the *Hancock* during the fall of 1779.

SCHOONER *WILLIAM*

The logbook of the schooner *William*, under the command of James Rhodes, provides some interesting insights from the point of view of an honest trading vessel going about its business when it was boarded by a British privateer. The captain of the captured vessel was none too pleased, as one might imagine, to have his dignity affronted, his ship plundered and his passengers mistreated and abused. The *William* was sailing off the Turks and Caicos Islands with a full cargo of beef, lumber, corn, onions, hay, fish, vegetables, butter and cheese. This would be a typical mixed load for a Connecticut vessel trading with the West Indies. This symbiotic trade between the Nutmeg State and the islands was well established by the middle of the seventeenth century. It provided the plantation system with necessary food and supplies and the New Englanders with sugar, molasses and rum.

The *William*'s logbook details the thoughts of its captain when his shop became a victim of a British privateer. On Sunday, August 11, 1793, at 4:00 p.m., a sharp-eyed crewman saw a swift-sailing schooner in the distance:

> [Captain Rhodes] *supposed him to be a privateer. She gave chase to us and at 6pm fired a gun. We hove to and they came on board and took my mate and people on board said schooner along with my vessel's papers. They left 6 or 8 hands with Armes and took the Brigantine from me.*
>
> *On Monday, August 12 at 2 pm the* [British] *captain came on board* [the *William*]. *As drunk as neadful* [sic] *they went to plundering the poare* [sic] *distressed passengers. At 8pm they left off till next morning.*

The logbook of the sloop *Mercury* details the goods that it lost to a seagoing plunderer. *Photo by Ray Guasp, courtesy of the Connecticut River Museum.*

At 6am they began again and plundered the stores and would have taken my money if the Second in Command, a man by the name of Thomas Smith of Bermuda had not interfered. The schooner privateer was named the Doris, but was also called the Kate of Bermuda and was commanded by Captain Brown Low. They overhauled my trunk looking for the money.

On Tuesday August 13, 1793 at 4pm they left off plundering. They threatened me to unload all my cargo if I didn't tell them where all the money was. They also took one of my hands out of me against my consent. They also took in money and plate worth the amount of 10 thousand dollars. We finally got underway at midnight and by 6 am were under the lee of the island.

This account is interesting on several levels. It basically demonstrates that the interactions between the privateer and his prey were calculated to avoid

violence whenever possible. At no time were physical threats issued, nor does it seem that any crew members or passengers were harmed. The situation was clearly defined, and the actors knew their roles and lines. Captain Rhodes does not even seem particularly angry at the unfortunate turn of events that befell him. His matter-of-fact narrative in the logbook would indicate that he saw the plundering of his ship as business as usual. It is interesting to note that just as they often flew more than one flag as a ruse, the privateer vessel also had more than one name.

As was the custom of stolid New Englanders, Captain Rhodes expresses very little emotion throughout the pages of his logbook. The only outburst of strong feeling that readily comes to mind was in the recounting of New Year's Day 1794. Rhodes claimed that it is a "mighty sorry day for us. The reason is that it is mighty cold and the wind blows so hard that Sam, the Cook, says we can have no victuals cooked. So we eat raw pork and drink grog. We hope to soften some pork in order to make the year more to our satisfaction." Being plundered evoked no emotion, but the lack of a hot meal on New Year's Day was a cause for gritted teeth and a superstitious sailor's belief that the tenderness of the year's first dinner will portend its upcoming events.

The logbook portrays the British privateers as being under the influence of strong drink. Since rum was, in many ways, the most important Caribbean commodity, it is interesting to note that the privateers and sailors of the period are rarely depicted as being drunk while they are at sea. Maclay, in his seminal work *A History of American Privateers*, portrays privateer men as notorious imbibers, famous even among the ranks of notably bibulous sailors for their ability to tipple while in port. Yet he never mentioned drinking

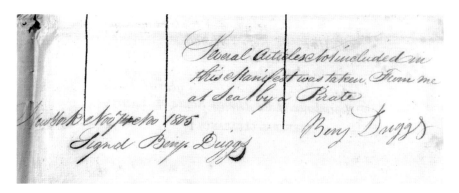

The signature of Captain Benjamin Driggs attesting that his cargo was stolen by a pirate. *Photo by Ray Guasp, courtesy of the Connecticut River Museum.*

aboard a vessel. While the Royal Navy had limits as to each man's daily grog ration, we can assume that the skipper of the *Doris* (aka *Kate*) was a bit more lenient in his parceling out of spirits.

It is also worthy of note that this raid on the schooner *William* occurred in 1793, after the Revolutionary War had concluded and while Britain and the United States were presumably at peace. The conclusion that can be reached is that the naval war between the two countries did not really end with Cornwallis's surrender at Yorktown. The fact that the drunken British captain, Brown Low, took one of the *William*'s seamen and impressed him into his own crew is a telling precursor of one of the key issues that led to the War of 1812. It was that war that finally put an end to naval enmity between Britain and its former colonies.

THE *HANCOCK*(S)

One of the interesting phenomena associated with developing information about Connecticut privateering vessels is the fact that in some instances, more than one ship had the same name. For example, *Hancock*'s name during the Revolutionary War was due to the patriotic activities of John with the famous signature. At least two Connecticut privateers carried his proud name into action against the British. One was a sloop and the other a brig. Original documents at the Mystic Seaport Maritime Museum detail the processes and regulations that were set forth by the owners and bond holders prior to the *Hancock* sloop's cruising. As the crew was recruited and signed on, they had to agree to the following conditions:

> *We the Subscribers, for and in consideration, of our monthly wages and privaledge* [sic] *unto us granted as fulfilled unto our respective names, do engage and by these presents do faithfully promise to perform a voyage on board the Letter of Marque Sloop Hancock, now laying at anchor in New London Harbor, whereof Joseph Conkling is Master, Captain unto to* [the] *Island of Guadeloupe or else where, as owner may order or occurrences may make it convenient in the West Indies and back again unto said port of New London:—and in every respect, faithfully to demean and behave ourselves as good men in our particular stations should and ought to do:—and to obey all commands of the Captain, and other officers and on failure and misconduct to be punished and forfeiture of wages, privileges,*

Many New London shipping firms owned and bonded privateers. ©*Mystic Seaport.*

shares and such other punishments as the Captain shall think the crime to merit—all prizes that shall be taken, two thirds shall belong to the owners, the other third shall be divided among the sloops company, according to custom in such case—all officers to be appointed by the Captain only who has full powers to displace such as he finds unfit—in case of the Captain's death, then the command to devolve to next in command for the faithful performance of which we have hereunto set our respective names. Day and date below.

The clause requiring the crew to behave themselves stands out in light of the reality that privateer men were noted for their unruly behavior, especially in the taverns and public houses where they would find themselves when in port. The captain and officers on privateering vessels were challenged to maintain shipboard discipline among crews of rowdy young men who were full of themselves and basking in the newfound ideas of the promise of riches, freedom and liberty.

On December 30, 1780, Captain Joseph Conkling (one of a family of three privateer captains) received the following orders from the sloop's owners at New London. They point out the fact that privateers were very

often cargo vessels as well as armed attackers of enemy shipping. Conkling's orders almost make the privateering aspects of his voyage seem to be an afterthought. Certainly, from the owner's point of view, a profitable trading venture coupled with a prize or two would be the best of both worlds:

Sir, Our sloop Hancock which we have given you the command of being now completely fitted out with a valuable cargo…you are ordered to the Island of Martinique or such other islands as circumstances may admit, when, if matters suit, dispose of your cargo to the best advantage and lay out the proceeds in good rum and ballast your vessel to return to New London or the first safe port in the New England states, and inform us immediately if your modicum of rum cannot be obtained at Martinique, Dominica or Guadeloupe, you may either send a neutral vessel after the rum, over yourself as you judge best. If matters should not be best at Martinique, you are at liberty to proceed where you judge most beneficial for the interest of the owners. Should you be fortunate enough to make any captures, order them where the cargo shall just suit, at same time remembering to have all prizes sent here, especially these that will answer this way. In case you are unfortunate as to leave your [obscured] then load with articles you think will be most profitable in an American market. By no means be taken with your [obscured] on deck as we would have the ship come back at all hazards, if nothing else, if common can be assured…you have leave to purchase six guns more as you think best. If rum cannot be obtained on reasonable terms, and good Bahia tea can, at four shillings lay out the most of your cargo therein…be careful to let us hear from you by the way. Have a good successful voyage and safe return to your friends and owners.

The sloop's first voyage was a success for owner Giles Mumford. It proceeded to French Martinique, sold its cargo at a profit and returned to New London laden with rum. Its second voyage was more implicitly a privateering venture. Sailors were recruited under the slogan, "Now for a Fortune!" It patrolled Long Island Sound in company with two other Connecticut privateers, *Hampton Packet* and *Fiery Trial*. A British galley and whaleboat had captured the American schooner *Peggy* near the mouth of the Connecticut River. They were no match for the trio of Connecticut privateers, however, and the *Peggy* was recaptured and the galley taken to Stonington as a prize. The sloop *Hancock* later captured the British brigantine *Lyon* on its way to New York to aid in the evacuation of British forces. It was taken to New London and libeled as a prize.

The other Connecticut privateer named *Hancock* carried eighteen cannons and a crew of slightly more than one hundred men. Its original name was the *Whim*, but it was renamed in the spate of patriotic fervor generated by the Revolution. It was owned by a consortium that included the Howland and Coit Company of Norwich, Thomas Mumford and Joseph Packwood. At various times it was under the command of Captains Peter Richards, Lodowick Champlin and Hezekiah Perkins. Commissioned in July 1782, it had a successful career that included nine voyages that took it to Maryland, Virginia and the Danish West Indies.

The *Hancock* cruised in company with other Connecticut privateers: the *Randolph, Young Cromwell* and the brig *Sampson*. In August 1781, they chased the British sloop *Swallow* and its prize, the brig *Venus*, toward Long Island, where the English drove their ships ashore and the crews escaped by land. Both vessels were burned to the waterline by the Americans. It also captured a British sloop in conjunction with the Connecticut privateers *Deane* and *Active*.

The *Hancock* was in New London Harbor when the British launched their large-scale raid on the Connecticut privateer fleet. Peter Richards, its captain, rushed to Fort Griswold to engage the attacking Redcoats. Alas, he was among those killed after the gallant defenders had surrendered. He was killed in retribution for what the British saw as American duplicity. *Hancock* was one of the vessels fortunate to have escaped upriver. Even though its captain had been killed, it was able to regroup to fight another day. Richards was replaced by Lodowick Champlin, a scion of an old Connecticut family with a long history of maritime activity.

Under his command, it sailed for the West Indies with the Connecticut privateer *Marquis de Lafeyette* on what appears to have been a trading/privateering voyage. Upon returning to New London, it promptly went back to sea in company with the privateer *Randolph* and the privateer schooner *Eliza*. The three Connecticut vessels easily overcame the British brig *William* and took it for a prize. The *William* was heavily laden with a cargo of tobacco bound for Europe. It had been captured and recaptured several times during the war; the *Hancock* and its fellow Connecticut privateers brought it to New London to be libeled as a prize.

The British transport *Thetis* was *Hancock*'s next victim. On its way from New York to Charleston, it was captured. It had previously been an American vessel. On this voyage, it had a valuable cargo of spirits and foodstuffs. It also was taken to New London as a prize. After a quick turnaround, Champlin got the better of a schooner named *Mercury* on its way to the Bahamas. Champlin had a close call shortly thereafter. He was forced to throw some

of his cannons overboard to gain enough speed to outrun the much larger British vessels that were chasing him.

The *Hancock* ended its career as a merchant vessel, plying the route between New London and St. Croix in the Danish West Indies. As a privateer, it was eminently successful, having taken five valuable prizes. Save for the execution of its captain during the Battle of Groton Heights, it managed to take those prizes with a minimum of casualties and damage.

THE *AMERICAN REVENUE*

This ship certainly lived up to its name. The Connecticut sloop *American Revenue* was one of the most prolific profit-making privateers of the Revolutionary War period. It was originally built in Bermuda as a trading vessel but wound up in New England early in its career. The *American Revenue* was then commissioned as a privateer. It was owned by Nathaniel Shaw and Company of New London, Connecticut. During the course of a busy three-year period between June 1776 and June 1779, it completed a dozen cruises in the waters of Long Island Sound and to ports as far distant as Surinam

Pistol made by Connecticut craftsman Simeon North—typical of those used by Revolutionary War–era privateers. *Photo by Ray Guasp, courtesy of the Connecticut River Museum.*

in South America. It was not a large vessel, rated at sixty-five tons, and it carried a relatively light armament of eight four-pound cannons. What it lacked in size it more than made up for in sailing speed and the energy and enthusiasm of its officers and crew.

Its first privateer captain was Stephen Tinker, who had also commanded it when it was a merchant vessel, so he was familiar with its sailing qualities. Owner Nathaniel Shaw sent Tinker to Lebanon, Connecticut, to secure a privateering commission from Governor Trumbull. Tinker successfully completed that mission but was summarily replaced as the *American Revenue*'s skipper by another of Shaw's merchant captains, William Packwood. The reasons for the change of command are unclear, but Packwood continued to outfit the ship and recruit a crew for privateering purposes.

Its first cruise, which took place in August and September 1776, did not result in the capture of any prizes. It sailed in company with the Connecticut privateer brig *Defense*, but it did not have any contact with enemy vessels. Frustrated at the lack of prize money, the *American Revenue* returned to New London for further fitting out and took on the large quantity of supplies necessary for an extended cruise. It now shipped a total of twelve guns and a hoped-for crew of one hundred. Once again, Nathaniel Shaw ordered its captain to be replaced, this time by Samuel Champlin Jr. of New London.

It made a short trip over to Stonington, Connecticut, in the hopes of recruiting more experienced crewmen to fill out its ship's company. Instead of a successful recruiting session, Captain Champlin saw his command diminish rather than increase when two sailors jumped ship in Stonington. The slim pickings of sailors to be found at port motivated him to make for Martha's Vineyard for further recruiting. There, in Edgartown Harbor, he was able to fill out his crew roster and finally put to sea on November 2, 1776.

On this, its second foray, the Connecticut privateer's extraordinary success story began in earnest. After a brief but sharp skirmish, it was able to capture the British slave ship *Mary*, which was making its way back to England after depositing its human cargo in British West Indies. Disenchanted with conditions aboard the *Mary*, several of the English sailors manning the slaver quite willingly reversed their allegiances and signed on as crewmen of the *American Revenue*. Many of them stayed aboard the *Mary* as part of its prize crew when it was taken to be claimed as a prize, first to New Bedford and then on to New London.

Champlin then headed for Barbados, where he came upon and captured the brig *Athol*, under the command of Captain James Waddee. It was bringing a cargo of dried, salted fish from Canada to the British islands in

the Caribbean to feed the slaves who were the economic backbone of the sugar cane industry that was so profitable to England and its island colonies in the eighteenth century. The *Athol* was put in the charge of a prize crew, which took it up the Atlantic coast to New Bedford, Massachusetts. Safely back in New England, it was successfully libeled to the benefit of Nathaniel Shaw and Company.

The *American Revenue* continued to plague the supply line that connected Britain to its Caribbean colonies. It captured the schooner *Two Brothers* as the English vessel made its way from Ireland to Jamaica with a cargo of food. The *American Revenue*'s mate, Lieutenant William Leeds, was put aboard it as prize master, and it headed up the Atlantic coast toward Connecticut. As it neared New London, the captured vessel was spotted by a British man-of-war, and a hot pursuit ensued. As his only possible means of avoiding capture, Lieutenant Leeds ran the *Two Brothers* hard aground on a beach near Westerly, Rhode Island.

Hoping to salvage whatever they could, the Americans began to hastily unload their prize's cargo. But the British warship had placed itself in a position to rake the beached boat with withering cannon fire. Fearing for their lives, the disappointed prize crew abandoned the boat that had been placed in their charge and headed inland. There they summoned some of the local militia, who set out toward the shipwreck with a few fieldpieces of their own. The British, meanwhile, had come ashore and were attempting to free the ship from its sandy berth. When they were not able to refloat the vessel, they set it on fire and rowed back to the safety of their warship, which sailed away before the Patriots could fire upon it.

Still in warm southern waters, the *American Revenue* was badly in need of resupply. The Yankee privateer especially needed to restock its stores of wood and water, the indispensable necessities of sailing ship life. The unsympathetic governor of Dutch Surinam proved to be somewhat surly toward the Americans and their cause. The recalcitrant administrator summarily turned down their anxious requests for supplies. Captain Champlin was compelled to resort to sneaking ashore to fill his depleted water casks and surreptitiously sawed several cords of lumber under cover of darkness.

The Connecticut privateer's successful hunting fortunes continued to flourish when it was able to capture the money-laden brig *Sally* on its way to Trinidad and Tobago with a cargo worth more than £30,000 sterling. Captain Champlin put aboard a prize crew under the command of William Powers and ordered it to proceed to New Bern, North Carolina, to be libeled. There was some confusion as to whether it belonged in New Bern

or Charleston, South Carolina, and apparently the situation was made more muddled by Prize Master Power's monumental intemperance. The issue was further complicated when a claim came forth that it was, in fact, an American-owned ship all along and therefore not subject to capture. Years of contentious litigation followed.

Champlin finally returned to New England for a much-needed refitting of the *American Revenue*. He joined Connecticut captain Samuel Smedley of the *Defense* in Bedford, Massachusetts, where they both saw to the revivification of their respective vessels. They were able to use equipment cannibalized from some of their prizes to strengthen their vessels. Captain Champlin was able to bask in some professional and economic glory because he had brought back to port prizes that totaled almost £5,000 sterling.

Ready for sea once again, the redoubtable captain put into the island port of Nantucket in the hopes of recruiting more seasoned sailors to fill out his ship's roster. Not only were crews of capable seamen difficult to come by, but also wartime shortages were beginning to create scarcities of basic necessities for an extended cruise. One of the situations that Champlin decried was his inability to purchase sufficient quantities of vinegar, a must for the preservation of food aboard ship.

Finally finding enough sailors and foodstuffs, the *American Revenue* made its way to the Caribbean once again. On this cruise, it sailed in company with the Rhode Island privateer *United States*. They captured the brig *Mary Ann* on its way to Ireland with a cargo of Caribbean rum. The *Mary Ann* was sent to Boston under the charge of a prize crew and was libeled, turning a tidy profit for the mariners and owners. Shortly thereafter, the *American* privateers captured another rum-laden schooner, the *Nancy*, and sent it to New London for prize money. The capture of the *Rebecca*, loaded with sugar, soon followed. It was also sent to Connecticut under the supervision of a prize master.

Captain Champlin once again put in to Martha's Vineyard to fill out his crew list. Weathered in to his slip due to a long bout of fog and foul winds, he finally sailed in company with the privateer *Revenge* and quickly ran down and captured a valuable prize, the ship *Lovely Lass*, reputed to be worth upward of £25,000. The *Lovely Lass* was sent to Boston with a prize crew and duly libeled. This was to be the last cruise for Captain Champlin aboard the *American Revenue*. He was replaced by William Leeds of Groton, Connecticut.

Leeds captured one prize, the schooner *Juno*, on its way to Quebec with a load of salt. The *American Revenue* also aided in the salvage of the *Marquis*

of Rockingham, which went aground on Gardiners Island. Working in concert with the Connecticut privateer *Governor Trumbull*, it was able to save some sails and rigging from the stricken ship. Several British seamen froze to death on the frigid beaches of the island as December gales thrashed Long Island Sound into a frenzy of white caps and frozen spray.

William Leeds continued to add to the sterling record of the *American Revenue*'s success. In short order, he captured the schooner *Polly* with a load of tobacco. He then took the British privateer *Sally* and confiscated its guns and ships' stores. His next victim was the sloop *Dispatch* on its way to England laden with sugar and rum. This successful capture was followed by the taking of another schooner, the *Proteus*, which was full of tobacco and tar. Leeds and his crews received tidy sums for their efforts, as well as accolades from the ship's owners and their fellow Patriots.

In June 1779, Samuel Champlin was back in command of the *American Revenue*. He took up where he had left off in terms of fruitful hunting. He recaptured an American privateer that had fallen into British hands, the *Berkley*. He also captured the privateer that had captured it, the *Sheela*, and sent it to New London to be libeled. At this point, a feisty contingent of Champlin's crew developed some major grievances, and the *American Revenue* was soon no longer a happy ship. A large number of crewmen signed a petition stating that they were willing to give up their share of prize money if they could immediately be discharged from the ship's company. This was an extraordinary set of circumstances. Privateering sailors usually did not give up their hard-earned prize money without severe provocation.

Champlin had one more successful capture before his luck finally deserted him. He overhauled and took the eighty-ton schooner *Carolina* and sent it to New London to be libeled with a cargo of timber and tobacco. The schooner and its cargo were sold at auction on August 11, 1779. The *American Revenue* then continued to search for prizes in company with the Connecticut privateer *Hancock* in the waters off New York and New Jersey.

It was there that they spotted an armada of British warships including the frigate HMS *Greyhound*. Both the *Hancock* and the *American Revenue*, knowing that they were no match for the much larger English vessels, decided to make a run for it. They jettisoned their cannons, water and most of their supplies. The faster-sailing *Hancock* managed to get away, but the *American Revenue* was obliged to heave to after coming under fire and begrudgingly struck its colors and surrendered. Thus ended the remarkable career of a Connecticut privateering vessel. Captain Champlin was taken to New York as a prisoner but was later exchanged for the crew of the *Sheela*.

THE MINERVA

The very first privateer to be officially commissioned by the Connecticut General Assembly was the *Minerva*. It was built at Rocky Hill, Connecticut, and owned by William Griswold of that town. Griswold had a career that was typical of those who grew up near the water in a time when ships and shipping played a large and important role in colonial society. Young William ran away to sea as a boy. He rose through the ranks and eventually served as mate on several English vessels. He invested part of his wages wisely and eventually developed a very successful sail loft in London, accumulating a modest fortune and solid social contacts.

While maintaining business interests in England, William Griswold returned to New England as a wealthy man who still had an eye for the main chance. He began to buy into shares of ships and voyages and sailed as captain on several voyages to the West Indies. He became a business partner of Barnabus Deane, the brother of noted Patriot Silas Deane, for whom a highway in Rocky Hill is named to this day. He constructed the *Minerva* and commissioned it as a sixteen-gun brig. Its career was an interesting and checkered one. Given the tumultuous time in which it sailed, it ultimately must be looked on as a successful ship, though its path to success was not an easy one.

Command of the *Minerva* was turned over to Captain Giles Hall. Governor Jonathan Trumbull of Connecticut, who commissioned several privateers, issued a letter of marque to him at the request of the legislators. In part, Trumbull's orders called for Hall to "sail with all possible dispatch on a cruise to the St. Lawrence or thereabouts in quest of two vessels from England bound to Quebec with arms etc.…The enterprize, as yet, remains a profound secret with us and the orders given to Capt. Hall are not to be opened until he is out of sight of land. The Minerva will sail in a few days…J. T——l."

Outfitting a sailing ship for a privateering voyage presented several logistical and supply challenges. First and foremost, it had to carry enough food to keep its crew alive while it was at sea. In the time before pasteurization and refrigeration, victuals needed to be salted or smoked to sustain the crew after the fresh food initially shipped ran out. One of the staples that served to keep sailors alive was bread. Although it became weevily and often was the consistency of a rock, it did provide minimal nutrition and could last a long time. After its launch and during its outfitting, *Minerva*'s first major problem was bread related.

Shortly before it was to sail on its maiden voyage, Griswold contracted with a baker in Durham, Connecticut, to supply the newly minted privateer with

five thousand pounds of bread. As the baker was completing the order, his house, which also contained his bakery and storage area, burned completely to the ground. This left the *Minerva* without the necessary provisions to put to sea. Captain Giles Hall had officially assumed command of the vessel, and the bread shortage became one of the major problems that plagued the ship in its early days.

Captain Hall eventually found an alternative source of baked goods and after several delays assembled his crew and proceeded down the Connecticut River in the hopes of capturing some rich prizes and making their fortunes, as well as garnering some fame in the process. Giles Hall, however, soon found out that some of his stalwart mariners were not quite as stalwart as he might have hoped for. Excited by the prospects of his voyage, Captain Hall cheated a bit and opened up the sealed packet containing his orders while he was still in the Connecticut River, well within sight of land. When the crew realized that their captain was bound for the St. Lawrence, rather than staying close to home in Long Island Sound, where they believed they would be cruising, things turned unpleasant very quickly. Before the *Minerva* cleared the mouth of the river, its crew rose up in a nonviolent mutiny and refused to sail the vessel out into Long Island Sound, much less all the way to the St. Lawrence River.

It turned around and made its way upriver (not always an easy passage) back to Rocky Hill. Owner Griswold was forced to regroup. Command was turned over to a captain named Ephriam Bill. Bill assembled a crew that was willing to follow his orders regardless of where they might lead. He put to sea and captured several thousand tons of British shipping. During Bill's tenure as captain, the *Minerva* was considered to be part of the Connecticut navy and, as such, was not strictly speaking a privateer, although as we have seen and will see, the flexible military and naval identities of the time often blur and overlap with private enterprise.

After Captain Bill left the ship, it became an unabashed, full-fledged privateer under the command of the legendary captain Dudley Saltonstall. His ability to capture British ships proved to be an insufferable thorn to the English and resulted in some serious retribution that was visited on the town of New London during the Battle of Groton Heights. The loss of the schooner *Arbuthnot*, which carried a valuable cargo of tobacco and enriched Saltonstall and his crew, was particularly galling to the British, since soldiers without their tobacco are known to get a bit tetchy.

The last straw from the Loyalists' point of view, however, was the capture of the ship *Hannah* by the *Minerva*. The *Hannah* had a cargo that was valued

at more than $400,000 in eighteenth-century currency (millions in today's money). The British retaliation, as we shall see, was devastating to the cities of Groton and New London. The *Minerva* continued privateering after Saltonstall left its command. Captain James Angel took control of its quarterdeck and was able to recapture the American brig *Rose*, which had been taken by the English and was on its way to a prize port. So, after a shaky start, the *Minerva* went on to have a proud career as a privateer. Its impact on British shipping was palpable, and its officers and men acquitted themselves bravely and efficiently.

Two Privateers Named Phipps

Although a decade apart in age, and apparently unrelated, David and Daniel Phipps were Connecticut privateers whose lives had many very similar currents and crossings. They both worked their way up to captaincies in privateers. They both were captured several times, imprisoned and paroled by a variety of enemies. Each had several successful voyages as a privateer, taking many enemy ships, cargoes and prisoners. They both lived to ripe old ages and finally retired from the sea to live in New Haven, Connecticut.

David was the older of the two. He was born in Maine in 1741 but settled in New Haven as a young man. He quickly rose through the ranks and became captain of the West Indies trading sloop *Industry* at the age of twenty-three. He then assumed command of the New Haven–built sloop *Dearing*, carrying on the traditional Connecticut-based trade with Barbados consisting primarily of fish, livestock, barrel hoops and staves. The Revolutionary War interrupted his career as a merchant captain, and he seamlessly transferred his seagoing skills to warships and privateers. He served on a succession of New England–based vessels, including the *Providence*, the *Alfred*, the *Raleigh*, the *Warren*, the *Trumbull*, the *Boston* and the *Confederacy*.

During the course of the war, David Phipps was taken prisoner and exchanged for British officers at least three times. In 1776, he signed on as master of the *Alfred*. In conjunction with a cousin of his wife, he raised a crew of more than one hundred men in New London and sailed south to join a fleet of eight other ships to attack British shipping. They were iced in on Delaware Bay for an extended period of time but eventually made their way free and proceeded to the Caribbean, where they had a successful cruise, taking several prizes. Phipps served as sailing master on more than

one of the vessels during this cruise. They captured large quantities of rum, coffee and sugar, as well as prisoners. In all they took seven British ships, two of which were recaptured by the enemy.

Upon his return to New London, he served under Captain Dudley Saltonstall on the *Trumbull*. He then transferred to the *Warren* and later the *Raleigh*, only to be captured yet again by the British. After he was repatriated, he entered formal naval service on the frigate *Boston* and the ship *Confederacy*. Upon completion of his naval service, Phipps was given command of the Connecticut privateer *Hetty*. It carried a crew of thirty-five and mounted eight cannons. It was owned by a New Haven company, and its primary area of patrol was western Long Island Sound. He later commanded the privateer sloop *Rebach*, a slightly smaller and less well-armed vessel.

After the war, Phipps continued his seafaring ways and commanded several merchant ships engaged in trade up and down the Atlantic coast and the Caribbean. He was taken prisoner, yet again by a French privateer, when he was in command of the schooner *Lucy*. The *Lucy* was retaken by a British frigate, and Phipps made his way back to New England. He was one of the first captains to successfully transition from sail- to steam-powered vessels. In 1817, he became the sailing master of the steam frigate *Fulton*, at the dawn of a new age in seafaring. He died in New Haven at the age of eighty-four, a seaman who lived a life full of adventure during a seminal period in our nation's history.

SOME HISTORIANS MISTAKENLY CONFLATE David Phipps with Daniel Goffe Phipps. (To further complicate matters, there was a British navy captain named Phipps who was contemporary with the two American Phippses.) Daniel Phipps was sent to England as a child and later came back across the Atlantic and lived in Georgia and South Carolina. His patriotism put him at odds with his Loyalist relatives, and he made his way north to New England to enlist in the Revolutionary cause. He was returning from a privateering expedition to the West Indies when his ship was captured by the HMS *Rose* under the command of Captain Wallace. He was put in prison in Boston during the Battle of Bunker Hill and later returned to the *Rose* as a prisoner at Newport, Rhode Island.

Phipps then escaped by jumping over the side of the ship and swimming to shore. He made his way to Connecticut, where he volunteered in a company of Connecticut militia. He served for several months under Captain Thatcher and was involved in several actions in the New York City area, having marched down the shore of Long Island Sound to engage the enemy. They successfully captured many cannons and other key pieces of

military equipment. Marched back to New Haven, Phipps was discharged from the militia and once again took up his seafaring ways.

He enlisted as a sailor aboard the privateer *Defence* (also written as *Defense*) under the famous Connecticut captain Samuel Smedley. The *Defence* sailed in tandem with the Essex-built *Oliver Cromwell*. They captured two English vessels, the *Admiral Kessel* and the *Cyrus*, and sent them into Boston as prizes. They had to rig up one of the boats that the *Cyrus* carried on deck to accommodate the overflow of prisoners. Phipps was discharged from the *Defence* in South Carolina but soon returned to the sea, this time as an officer.

He took command of a sixty-ton brigantine named the *Nancy*, carrying ten guns, and received a commission from Congress to go privateering. His commission authorized him to "attack, subdue and take all ships and other vessels carrying provisions, or munitions of war to any of the British armies, and also all vessels belonging to the inhabitants of Great Britain." He sailed up the coast with a surprisingly small crew. They were few in number but apparently quite feisty, as they mutinied off Sandy Hook, and Phipps was compelled to put into New London to quell their uprising. He made a few forays out of New London in search of prizes but was constantly harassed and chased by British men-of-war and was bottled up in port most of the time.

He then took command of a New Haven vessel, the *Betsy*, an armed schooner. He received another commission from Congress that allowed him to sail as a privateer. He made several voyages to the West Indies as, essentially, an armed merchantman. He "cruised continually in the Atlantic Ocean, until the peace between Great Britain and the United States in 1783…I took no prizes with said schooner, but prevented several American vessels being taken by the enemy." Phipps had just returned from the island of St. Christopher when news of the peace became known to him in New Haven. There is little evidence as to his activities after the war. He applied for a pension based on his Revolutionary War service in 1830, so it is fair to assume that he lived well into old age.

THE YOUNG CROMWELL

Although it didn't enter the privateering service until June 1779, the *Young Cromwell* more than made up for its late start with a spectacular string of captures and prizes. It was schooner rigged and owned by Joseph Williams and Company of Norwich, Connecticut. In its two-year career, the *Young*

Cromwell was commanded by six different captains, including William Reed, who had served aboard the *American Revenue*. It made a total of eighteen cruises, primarily in the waters of Long Island Sound but also ranging as far as North Carolina and the French West Indies.

It carried ten cannons and shipped a crew of forty-five men. As was often the custom, its initial foray saw it sailing in consort with other Connecticut privateers. In this case, it teamed up with the *Hancock* and the *Beaver*. The three Patriot vessels captured the British brigantine *Nancy*, a one-hundred-ton prize. Among the people on board was a high-ranking passenger known as the commissary of prisoners. It was brought to New London as a prize along with its cargo of fish, oil and potatoes.

The fall of 1779 proved to be a busy time for the *Young Cromwell*. Teaming with the sloop *Retaliation*, it captured the sloop *Peggy* with a cargo of lumber. At the same time, it took the brig *Walpole* with a cargo of food destined to feed British troops in New York. It recaptured the Massachusetts privateer *Endeavour* and followed that with the recapture of the sloop *Fly*. All this was accomplished between September 8 and October 13. All its prizes were taken to New London to be sold at auction.

It was joined by the Connecticut privateers *Beaver* and *Gates* in October, and they soon sent two prizes back to New London, a sloop and a brig. Their names are lost in the mists of history, but their cargoes included fish, wine, salt and tobacco. *Young Cromwell* also returned to that port for a brief refit and to take on a new captain, Benjamin Hilliard.

Its next cruise, up to Newfoundland and down to New York, did not meet with its usual success. Not only were no prizes taken, but they were also set upon by a fleet of British warships and were forced to throw most of their cannons overboard in order to outrun the larger ships that would have surely sunk or captured it. The schooner safely managed to make it back to New London and underwent yet another change of command, with William Wattles once again taking charge.

It put to sea again in the company of the Connecticut privateer *Bunker Hill*. They encountered a rum-laden British privateer sloop named the *Dolphin*; the English vessel proved to be a tenacious foe, and there was a lengthy exchange of cannon fire that saw an American officer killed and several sailors severely wounded. At length, the day belonged to the Patriots, and the Connecticut privateers arrived in New London with their prize. There they licked their wounds, repaired the damage to their vessels and prepared to put to sea again. The *Dolphin* and its cargo were auctioned as prizes.

Sailing in concert with the Connecticut privateers *Hawk* and *Sally*, Wattles captured the large British ship *Jenny* with a mixed cargo that included coal and cordage. Again the prize was taken to New London, after which the *Young Cromwell* made a quick turn around and headed back to sea in search of more fame and fortune. It teamed up with the privateer *Hamlin* to run a schooner aground on Long Island. They were able to refloat it and sent it up the Connecticut River as a prize. *Young Cromwell* had a narrow escape from a British frigate that chased it to the mouth of the Thames River, but it was able to reach Norwich and safety.

The ship then went on an extended cruise. *Young Cromwell* was at sea for such a long time that people in Connecticut were concerned that it had been lost, sunk or captured. But it turned up safely in New Bern, North Carolina, with yet another prize full of wine and fabrics. It then sent another prize, the brigantine *Rochester*, to Newport, Rhode Island, as it made its way back up the coast to New England. It then made a sortie into its home waters of Long Island Sound, recapturing two vessels from New London that had been taken by the enemy, as well as capturing an enemy gunboat. It also recaptured the brig *Salem*, which was full of fish and lumber, and brought it back to Connecticut, where it was libeled. After a brief refit, the ubiquitous *Young Cromwell* was back to sea once again.

Working in tandem with the privateer *Kingbird*, it next captured the sloop *Tabitha* and a sloop commanded by a British officer, the *Dispatch*, that was carrying documents and mail to the English headquarters in New York. Unfortunately, the Royal Navy lieutenant was able to destroy most of the correspondence in his charge, but he was nonetheless taken prisoner and brought back to New London.

Working with the *Randolph*, *Young Cromwell* recaptured the brigantine *Society*, which had been taken from the Americans by the British privateer *General Arnold*, named for the perfidious traitor who did so much harm to the port of New London. It was brought to Norwich to be sold at auction with a cargo of flour and lumber.

In the never-ending game of captures and recaptures, Hilliard recaptured the brig *Neptune* that had been taken by the British ship *Assurance*. Its British prize crew was taken prisoner, and it was taken to New London. Turnabout being fair play, however, *Young Cromwell* recaptured a brig that had been taken by a British frigate. With a prize crew aboard, it made its way to Connecticut; its prize crew was surprised by another enemy frigate and was forced to take to the ship's boats and give up its recaptured capture.

Young Cromwell's success rate continued to soar. It took the schooner *Surprize* and an unnamed sloop in August 1781. It then took the sloop *Hazzard* with a load of lumber, along with the Connecticut privateers *Active* and *Randolph.* That same month, it joined in the pursuit of the Royal Navy sloop *Swallow* and its prize the *Venus*. Both vessels were run aground on Long Island and burned by the Americans while their British crews escaped.

At the beginning of September 1781, the Connecticut sea raider captured two ships (the *Achilles* and the *Williamson*) that were en route to New York with supplies for the British navy. Both of these valuable prizes were taken to New London along with their officers and crew. *Young Cromwell* then captured the brig *Peggy* and the British privateer schooner *Betsey*. These prizes brought its total number of captures to more than thirty, a remarkable record for such a relatively short career.

Alas, its string of successes came to an end under the guns of the British frigate *Amphion*. It was captured on November 23 and taken to New York as a prize. Its crew was sent to the prison ships, and many died there from the illnesses that raged in their fetid quarters. Captain Cook managed to escape by swimming ashore and returned to New London to take command of yet another privateer. He was recaptured by the British and sent to Bermuda.

THE INFAMOUS TRAITOR

Connecticut-born Benedict Arnold's name will forever be associated with disloyalty, treason and treachery. This former horse trader will ever be branded as the quintessential turncoat. He abandoned the cause of liberty and took up arms against his fellow colonists. His seditious conduct reached new lows when he was put in command of an extensive British force, the goal of which was to stamp out the pesky privateers of Connecticut once and for all. Privateering from the coves, inlets and rivers of the Connecticut colony during the Revolutionary War had reached a level of economic and logistical damage to the English forces that it was decided to completely snuff it out of existence. Arnold was charged with this task. The British also hoped that his attack would lure George Washington to the north side of Long Island Sound and distract him from his march to Virginia. New London was at the heart of Connecticut privateering. Many privateers slipped in and out of its harbor, and it was the primary port in the colony where prize ships were taken to be auctioned.

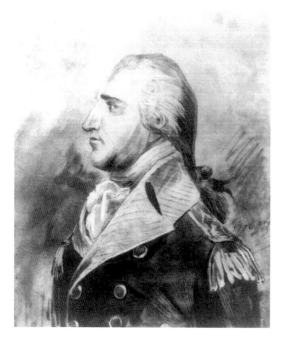

Benedict Arnold's name still evokes treason in America's memory. *Library of Congress.*

Benedict Arnold's homestead in Norwich, Connecticut. *From history.org.*

Hoping to deal the privateering port a crushing blow, the churlish traitor assembled a fleet of warships and manned it with 1,800 British soldiers, sailors and marines. Its objective was to seize control of New London Harbor and cripple its ability to support privateering. New London privateers had captured more than five hundred British ships, severely interrupting their supply lines and their ability to sustain troops and sailors. There also was an element of revenge involved in the planning of the attack. The British were smarting from the seizure of their ship the *Hannah*, which had been captured by the American privateer *Minerva* and its captain, Dudley Saltonstall, with a cargo worth upward of £80,000 sterling. Since the *Hannah* was taken as a prize to New London, the English were incensed at the town and its residents.

Their plan of attack was built around the destruction of the *Hannah* and all the other British prizes in the harbor. It also included the total destruction of the area's ability to raid English shipping. The plan was to demolish all the Yankee privateers in port and eradicate the large amounts of military and naval supplies stored in the town. The British also hoped to free the many prisoners of war who were incarcerated in the New London area and root out the festering causes of annoyance that the port continued to provide. A fortuitous shift in the wind from the southwest to the north, however, worked in the Patriots' favor, as it prevented the British fleet from penetrating as deeply into the harbor as it would have liked.

The harbor was guarded by three forts. Fort Nonsense and Fort Trumbull were on the west bank, with Trumbull under the command of Captain Adam Shapley. His orders essentially stated that if the fort came under direct attack by the British, he was to abandon his position and remove his troops across the river to Fort Griswold. When Benedict Arnold's troops, numbering upward of nine hundred, moved toward Fort Trumbull and its twenty-three defenders and fifteen twelve- and eighteen-pounder cannons, Shapley's gunners fired off one volley, spiked their guns and made for the shore. They cast off in three small boats and rowed across the Thames to the larger fortification on the eastern bank of the river.

After securing Fort Trumbull, Arnold marched his men upriver to the small redoubt poetically named Fort Nonsense. The Patriot defenders fired off several volleys of cannon shot, but they quickly abandoned their position as the numerous hordes of red-coated regulars and Hessian jaegers quickly overran the fort. The British captured six cannons from the fleeing Americans.

While these encounters were occurring on the west bank of the Thames, the wind once again shifted in the Patriots' favor as it came around again

The view that overlooks New London Harbor from Fort Griswold. *Photo by Carla Griswold Giorgio.*

Fort Griswold information sign detailing the key sites in the city of New London that were burned by the British. *Photo by Carla Griswold Giorgio.*

to the southwest. General Arnold had hoped to completely destroy the privateer and prize fleet anchored in the harbor. But just as the tide began to come in, the wind began to blow briskly upstream. This allowed several American ships to slip their cables and run up the river out of range of English artillery. The Yankee ships were able to make their way to Norwich, which ironically was Arnold's hometown. Since it was a Patriot stronghold, this flummoxed the turncoat general greatly, but he still had to consider the Yankee position on the east bank of the Thames.

Fort Griswold was situated on high ground in an area known as Groton Heights. The fort was under the command of Colonel William Ledyard, who led slightly fewer than two hundred troops. His contingent of defenders was also supposed to be supported by several local militias that were to assemble upon hearing a prearranged signal. Two cannon shots were the sign that would summon the surrounding Patriots to rush to the fort and reinforce its defenders.

But the signal was discovered by Loyalist intelligence agents in a network designed by the crafty Arnold. Totally unaware that his secret signal was compromised, Ledyard fired off two warning shots with his cannons to

The guns of Fort Griswold could not stop the British invasion. *Photo by Carla Griswold Giorgio.*

signal the militia to take up arms. Arnold immediately ordered his gunners to also fire a cannon shot. The militias heard the signal as three shots, a Patriot signal that meant a captured vessel was entering the harbor. The reinforcements of militiamen never materialized.

Fort Griswold was bravely defended against the British attack on New London's privateers. *Photo by Carla Griswold Giorgio.*

As a result, Arnold's troops easily subdued the city. He had issued orders that proscribed looting by his men but encouraged the razing of storage facilities and goods. Fires were set, and several explosions wracked the business district and spread throughout the community. A privateering vessel was among several ships that were burned. The carnage had a heavy impact on New London's commercial viability, but its excellent harbor helped it to survive the war and its aftermath.

While the town was burning, Lieutenant Colonel Edmund Erye was leading a force of more than eight hundred men against Fort Griswold and Colonel Ledyard's soldiers. Shooting down from Groton Heights, the defenders initially inflicted heavy casualties on the British invaders. The privateer captain Elias Halsey, who had some experience with artillery, was instrumental in coordinating the firing of the defender's big guns. But as their superior numbers allowed them to secure covered positions, the English dug in and kept up a fierce attack. Both sides traded fire until a fluke of circumstance changed the vector of the battle and ultimately sealed the colonists' fate.

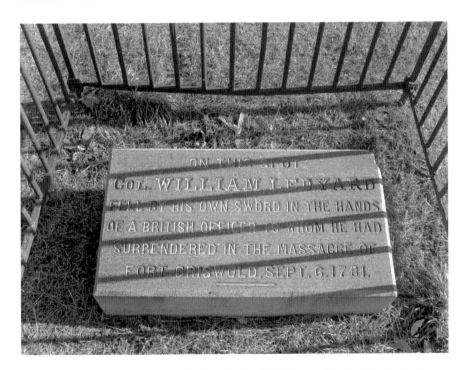

Colonel William Ledyard was killed during the Battle of Groton Heights. *Photo by Carla Griswold Giorgio.*

Above: Shot furnaces heated iron projectiles to make them more deadly. *Photo by Carla Griswold Giorgio.*

Left: The powder magazine was used to keep valuable gunpowder from exploding during attack. *Photo by Carla Griswold Giorgio.*

Fort Griswold's gun emplacements were positioned to defend New London Harbor. *Photo by Carla Griswold Giorgio.*

A random shot from a British musket just happened to hit the halyard of the flag that was flying over the fort. Without its supporting rope, the Americans' colors fell from the top of the flagstaff—the universal signal of surrender. Thinking that they had won the battle, the British troops stood up in plain view and began to walk up to the fort. Having no idea that their flag had failed, the defenders began to mow down the attackers, now sitting ducks.

The British thought that the Yankees had resorted to foul play and redoubled the fierceness of their attack. Eventually they overwhelmed the fort and gave no quarter to the defenders. As they tried to surrender, the colonists were bayoneted and shot. Well over half the men who defended the garrison were killed or wounded. Colonel Ledyard died in the battle. One of the Connecticut soldiers spread malicious rumors about English cruelty and the torture of captive soldiers. He told a version of the story that came to be widely believed, that Ledyard was decapitated by his British counterpart with his own sword after he had surrendered it to the victor of the battle.

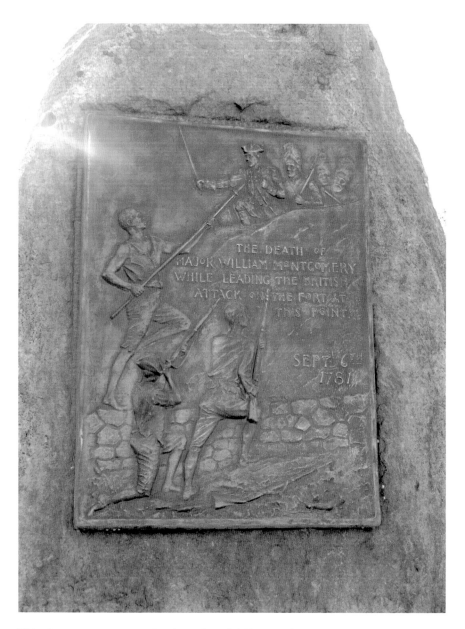

This plaque commemorates the place where British major Montgomery was killed by American fire. *Photo by Carla Griswold Giorgio.*

Opposite: Fort Griswold is now a Connecticut State Park, preserved for future generations. *Photo by Carla Griswold Giorgio.*

Even though the man recanted his story after the war, legend and lore clung to the story of Ledyard's beheading and other British atrocities. While the privateers of New London suffered a severe setback as the result of the raid, they still managed to put several ships to sea until the cessation of hostilities. Arnold's attempt to distract George Washington proved to be a

failure. Washington proceeded to Virginia with little thought of Connecticut and won the ultimate victory at Yorktown in the deciding battle of the Revolutionary War.

The privateers of Connecticut found little respite from their labors, even with the coming of peace. Trouble with France and Spain developed and required their skills and attention. The impressment of American seamen and other issues with British shipping simmered in anticipation of the War of 1812 and the disastrous embargo that preceded it. The port at the far eastern terminus of Long Island Sound still had some forays to run and some fighting to do.

Part III
The War of 1812

THE BRITISH SACK OF ESSEX

There is a quintessentially quaint village situated on the banks of the Connecticut River a few miles upstream from its mouth. Formerly known as Pettipaug (or Potipaug), this enclave of entitlement is now called Essex. Its motto is "The Best Small Town in America," and there are many who would agree that it well deserves that title. With a tree-girded main street lined with upscale shops and assiduously maintained eighteenth-century houses, one of the oldest inns in the country and shipyards that are homeport to fleets of the finest yachts afloat, Essex is almost a living anachronism. Its history is an integral part of its fabric of daily life. The Connecticut River Museum, dedicated to preserving this heritage, is nestled at the foot of Main Street, where the town meets the river. Needless to say, this charming village is quite a popular tourist destination and a town whose residents hold it and its history near and dear.

Every spring, the village celebrates the return of daffodils and trout lilies with a unique seasonal ritual. However, given that the tradition's origins are obscure, this celebration is never advertised. But each year, early in May, a parade led by a cadre of fifers and drummers in early nineteenth-century naval garb makes its martial way down Main Street to the boat landing adjacent to the Connecticut River Museum. There, where the events commemorated actually occurred, the most famous day in Essex history is remembered and relived. This annual vernal celebration is affectionately

Mural by Russel Buckingham depicting the British burning the fleet of privateers at Essex. *Photo by Ray Guasp, courtesy of the Connecticut River Museum.*

known as "Loser's Day." It recaptures the memory of one of the most costly and devastating attacks on any American community in our nation's history.

The event that it memorializes is known alternatively as the Raid on Essex or the Burning of the Fleet. It rekindles the memories of the stirring events that took place on the night of April 8, 1814. On that fateful date, British sailors and marines under the command of Captain Richard Coote rowed ashore with muffled oars under the cover of fog and darkness. The Royal Navy sailors and their contingent of marines looted the town, burned its privateering fleet and made good their escape back downriver with only minimal damage and loss of life. It was a devastating blow to Connecticut's privateering and commercial interests.

The Embargo Act and the subsequent War of 1812 were crippling to the maritime commercial activities of Essex. They prohibited the town's ships from engaging in the lucrative coastal and West Indian trades that were the backbone of its economic success. With a large number of Essex-based ships, seamen and officers out of work, the lure of privateering loomed enticingly as an attractive, lucrative alternative to penury and idleness. The town was once not only a bustling port but also an active shipbuilding center. It was a relatively easy transition for its shipwrights

to put their skills into the construction of armed privateers instead of strictly trading vessels.

The powerful British navy had managed a more or less effective blockade of Long Island Sound, keeping Commodore Decatur's makeshift fleet bottled up in port. However, the fast and lively shallow-drafted privateers of the coastal and river towns often managed to slip past the jaws of the English bulldogs and roam the Sound and adjoining waters, wreaking havoc on British shipping whenever possible. Legend has it that the high command of the Royal Navy in the Sound was privy to very accurate intelligence about the number of privateers in Essex, both those that were lying at anchor and those being built on the ways.

While the true identity of the traitorous spy who provided that intelligence and gave away the town's secrets may never be completely revealed, one story identifies him as "Torpedo Jack." According to the legend passed down for centuries, Jack was a brave Patriot seaman who daringly took part in an attack on the British man-of-war *La Hogue* in New London Harbor. The scheme to blow up the warship was hatched by a New London privateer captain named Jeremiah Holmes. His bold plan was to tow a torpedo with a barge alongside the Royal Naval vessel, attach the explosive device to its hull and row rapidly away before it would explode and sink the enemy ship. However, the line towing the torpedo somehow became fouled with the anchor line of the man-of-war, and the bomb detonated prematurely, sinking only one of the British small boats.

La Hogue's prideful skipper, Captain Capel, was incensed that someone would attempt to harm his splendid ship. He sent out several small boats up and down the Sound in the hopes of capturing some of the perpetrators of the plot and bringing them to justice. One of these chase boats came upon a hapless sailor, whom the crew immediately dubbed "Torpedo Jack." Since he was rowing with muffled oars, heading for the mouth of the Connecticut River, Jack quickly became a suspect in the abortive bombing attempt. The misbegotten mariner was quickly clapped in irons and threatened with a cascading series of dire consequences if he didn't confess to the crime. Thinking that his very life was in jeopardy (and it probably was), Jack supposedly offered to guide his captors up the river to where the privateer fleet was located in return for his freedom.

British documents from the period, however, seem to partially exonerate poor Jack. These primary sources indicate that the turncoat was a paid spy who received a large sum of money in exchange for the information that allowed them to navigate their attack force up the river. He allegedly

provided detailed information as to the whereabouts of the vessels and stores that were the targets of the planned raid. The traitor may have been a local businessman named Glover. After the raid, he was accused of colluding with the enemy. His fellow citizens believed that he gave up vital intelligence in exchange for not having his sloop torched. Glover apparently accompanied the English down the river after their fiery mission was complete and was put ashore by them on Fisher's Island.

Still other stories speculate that the dastardly traitor was the jilted suitor of the daughter of one of the town's prominent citizens, who, in pain and anger, turned against his village to revenge his unrequited love. Other tales persist in the suspicion that the town's goods and boats were sacrificed to the invaders due to a series of secret handshakes and signs that passed between Captain Coote and one George Jewett, who was in charge of the local militia at the time. Coote had supposedly cut deals with fellow Masons in New York, sparing their ships from harm. The identity of the true spy may never be fully revealed, but as long as locals frequent the taproom of the Griswold Inn, there will be colorful musings as to his (or her) identity.

What is known for sure is that the fleet of warships blockading the Sound included *La Hogue*, the *Maidstone*, the *Endymion* and Coote's vessel, the *Borer*. Coote assembled a crack attack force of sailors and marines from this fleet and deployed them in rowing boats with swivel guns mounted on their bows. Their first task was to secure the fort at the mouth of the river in Saybrook to allow their boats a safe exit once their raid was complete. There had been a fort at this strategic site since the Dutch built a makeshift redoubt there in the very early seventeenth century. It was the site of the English stronghold, named Saybrook in honor of Lord Saye and Seld and Lord Brook. It was from this strategic base that the English deposed the Dutch, defeated the Pequot Indians and secured the river valley for their agriculturally minded settlers. Since the fort now sat on Patriot soil, the British invaders assumed that it would be well fortified and staunchly defended.

To their astonishment and good fortune, they found that the fort had been completely forsaken by the Americans. There were no personnel or armaments anywhere to be seen. This stroke of luck made their plans for escape after their assault far simpler and safer. Buoyed by these fortuitous circumstances, the navy men began to row their attacking armada up the Connecticut River. With wind and tide against them, the determined invaders nevertheless continued to doggedly row the six hard-earned miles upstream toward their target. They arrived at Essex at approximately 3:30 a.m.

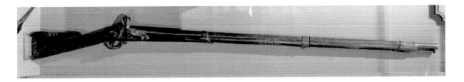

Musket made by the Federal Armory in Springfield, Massachusetts, in 1795. Family lore suggests that it was fired at the British by John Stokes, a ship's carpenter, in April 1814. *Courtesy of the Connecticut River Museum.*

There are some conflicting accounts as to what role the element of surprise played in the success of the British raid. Coote claimed that the townsfolk were on high alert, while some of the locals adamantly averred that they were taken completely unaware of the impending attack. There was some token resistance offered by the citizenry. A shot was fired by a land-based four-pounder cannon, and the defenders of Pettipaug managed to get off a few rounds of musket fire. These defensive measures were met by an overwhelmingly thunderous volley of British musketry and perhaps a few cannon shots from the swivel guns mounted on the British boats.

Surprised or not, the town's inhabitants found themselves in a very untenable position. The invaders had swivel guns full of devastating grapeshot, government-issued Brown Bess muskets, razor-sharp cutlasses, pistols and pikes. Outmanned and outgunned, the Pettipaug people had little choice but to agree to whatever terms Coote might deign to impose on them. A hasty agreement was reached in which the Americans would offer no resistance as the British looted their supplies and burned their ships. In return, the English agreed not to harm the citizens or burn their homes or other buildings.

In an act of pillage that still resonates when the locals recall the event, the British made off with a very large store of the town's rum. Rum was an extremely valuable commodity at the time. Very often it was considered to be an integral part of a sailor's or a shipyard worker's wages. It was a vital staple in colonial life, wherein drinking was done throughout the day but drunkenness was frowned upon. In addition to this spiriting off of spirits, the intruders absconded with an impressive amount of cordage. Hamstrung in their ability to defend themselves, the residents secretly dispatched messengers to alert and summon the militias of surrounding communities in the hopes of raising some resistance to the inevitable downriver escape run of the invaders.

Rope and rum were all well and good spoils of war from the British point of view, but their most important target was the town's burgeoning

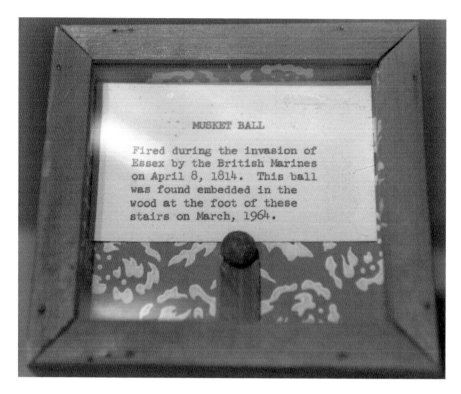

MUSKET BALL

Fired during the invasion of
Essex by the British Marines
on April 8, 1814. This ball
was found embedded in the
wood at the foot of these
stairs on March, 1964.

This musket ball fired by the British during the raid on Essex was found embedded in a local house in 1964. *Photo by Ray Guasp, courtesy of the Connecticut River Museum.*

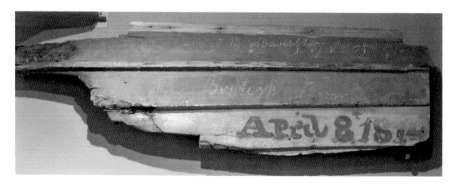

A plank from the *Osage*, one of the privateers burned at Essex. *Photo by Ray Guasp, courtesy of the Connecticut River Museum.*

privateering fleet. Armed with torches, pitch and axes, the marauding sailors and marines methodically went about burning the entire squadron of private armed vessels at anchor in the harbor and tied up to the town's docks

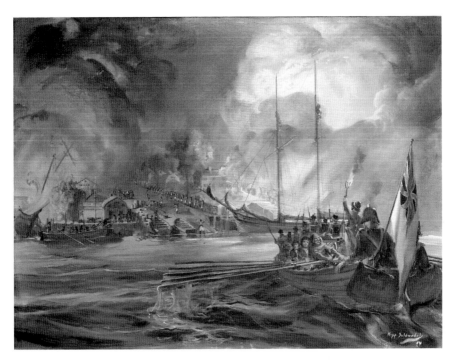

A painting of the British raid by Kip Soldwedel. *Photo by Ray Guasp, courtesy of the Connecticut River Museum.*

and shipyards. In total, the arson-minded military and naval troops burned twenty-five vessels and took two more as captives. Among the privateering boats burned were the *Osage*, the *Guardian*, the *Comet*, the *Emerald*, the *Felix*, the *Washington* and the *Thetis*.

The grandest prize destroyed by the British was the brand-spanking-new schooner *Black Prince*. Built by Captain Richard Hayden and rated at 315 tons, the *Black Prince* was touted in a New York newspaper as a "sharp schooner that would make an ideal privateer." There is some speculation that this article in the press may have initially aroused the British curiosity about Pettipaug and its privateers. The Englishmen also captured the schooner *Eagle* and the brig *Young Anaconda*. These two vessels were not burned but were instead loaded with the spoils looted from the town and taken downstream when the enemy finally left off their pillaging and plunder.

After their extremely successful raid, the British began their journey back down the river. This hazardous journey proved to be more difficult than their attack. Foul winds and an ebbing tide were set against their progress. The *Young Anaconda* ran hard aground on a sandbar. Unable to easily free

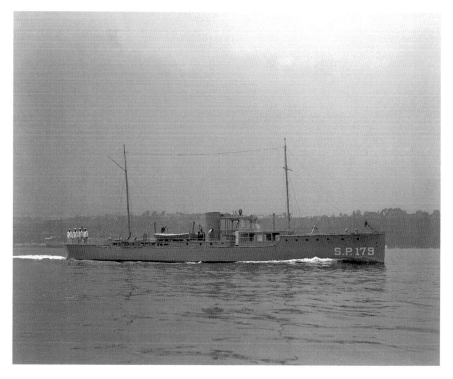

This early twentieth-century Coast Guard cutter, aptly named *Privateer*, patrolled areas where much privateering action had occurred in previous centuries. ©*Mystic Seaport.*

it, Coote ordered its cargo of ill-gotten gains to be transferred to the *Eagle* and then had the grounded brig put to the torch. The captain's problems did not end there, however. Alerted by the runners sent out from Pettipaug, the riverbanks were now lined by American militiamen armed with muskets and some cannons. The English were now on the defensive, with a deadly gauntlet to be run before they could reach the safety of their warships anchored off the mouth of the Connecticut River.

Captain Coote decided to anchor his fleet in the hopes of higher tide and the advantage of proceeding all the way out to the Sound under cover of darkness, rather than have his boats be exposed targets in the daylight. A major in the Lyme Militia, Marshe Ely, thinking that Coote was now a sitting duck, sent him a message requesting that the Royal Navy captain surrender to prevent bloodshed and save the day for the Patriots. The British officer declined to do so. Instead, he loaded the remaining cargo into his rowing boats. He then ordered the schooner *Eagle* to be set aflame. Once the sun set, the heavily laden British boats slipped down the river toward Long Island Sound.

Coote's passage was not as easy as he and his crews might have wished. Patriot troops continued to line the banks of the river. They had set several roaring bonfires to provide light with which to aim the increasing number of shoulder arms and artillery that were at their disposal. As they rowed furiously downstream, the British came under sustained attack from the shore. Two of the British marines were killed, and all of their boats sustained significant damage, though none was sunk. Even in retreat, the English were able to inflict some harm on the Americans, burning several of the Patriots' boats at Brockway's Ferry in Lyme. They were finally able to make their way out of the mouth of the river and rowed to the safety of their mother ships.

Although they were successful in their plundering of Essex, the British ultimately lost the War of 1812. After the American victory, Connecticut privateering came to a complete halt. Privateer ships were laid up or converted to merchant activities. The men who manned them often found themselves off the beach with limited career opportunities. The roar of cannons and pockets full of prize money became dim memories. It took decades for Connecticut to regain its prowess as a maritime mercantile entity. But the Age of Steam gave its ports renewed promise of passengers and profit. The brave men and their proud privateer ships that fought our country's enemies will always be remembered with pride and honor when old-timers share a glass in the taproom of the Griswold Inn on Loser's Day.

Selected Sources

Griswold, Wick. *Griswold Point: History from the Mouth of the Connecticut River.* Charleston, SC: The History Press, 2014.

———. *A History of the Connecticut River.* Charleston, SC: The History Press, 2012.

Hog River Journal 7, no. 2. "Cruising the Thimble Islands" (Spring 2009).

Huggins, Ronald V. "From Captain Kidd's Treasure to the Angel Moroni: Changing Dramatis Personae in Early Mormonism." In *Dialogue: A Journal of Mormon Thought* (n.d.).

Jameson, W.C. *Buried Treasures of New England.* Little Rock, AR: August House Publishers, 1998.

Kuhl, Jackson. *Samuel Smedley, Connecticut Privateer.* Charleston, SC: The History Press, 2011.

———. "The Whaleboatmen of Long Island Sound." *Journal of the American Revolution* (November 2013).

Love, William DeLoss. *The Colonial History of Hartford.* Hartford, CT, 1935.

Maclay, Edgar S. *A History of American Privateers.* New York: D. Appleton and Company, 1898.

MacMullan, Eugene C. *Letter of Marque Issued by Jonathan Trumbull, Governor of Connecticut, May 1, 1781.* Available at the Totoket Historical Society, 2007.

Merchant, Gloria. *Pirates of Colonial Newport.* Charleston, SC: The History Press, 2014.

Middlebrook, Louis F. *History of Maritime Connecticut during the American Revolution.* Salem, MA: Essex Institute, 1925.

Ritchie, Robert C. *Captain Kidd and the War Against the Pirates.* Cambridge, MA: Harvard University Press, 1986.

Skinner, Charles M. *As to Buried Treasure and Storied Waters, Cliffs and Mountains: Myths and Legends of Our Own Land.* Project Gutenberg Ebook, 2004.
Van Dusen, Albert E. *Connecticut.* New York: Random House, 1952.
Wilbur, C. Keith. *Pirates and Privateers of the Revolution.* Chester, CT: Pequot Press, 1984.

WEBSITES

www.awiatsea.com.
www.bartleby.com.
www.battleofgrotonheights.com.
www.bio.umass.edu.
www.boston.com.
www.bravenet.com.
www.clickamericana.com.
www.connecticuthistory.org.
www.continentalnavy.com.
www.ct.gov/deep.
www.ctgenweb.org.
www.digitalcollections.nypl.org.
www.digitalcommons.unl.edu.
www.doublegv.com.
www.dunhamwilco.net.
www.freepages.genealogy.rootsweb.com.
www.hartfordinfo.org.
www.history.navy.mil.
www.hogriver.org.
www.jcs-group.com.
www.library.mysticseaport.org.
www.longislandgenealogy.com.
www.longwood.k12.ny.us.
www.losttreasure.com.
www.nndb.com/people.
www.patch.com.
www.sacred-texts.com.
www.theday.com.
www.thepirateking.com.
www.threedecks.org.
www.thunting.com.
www.warof1812ct.org.

Index

About the Author

Wick Griswold teaches the sociology of the Connecticut River at the University of Hartford's Hillyer College. He has been a short-order cook, commercial fisherman, construction worker, truck driver, dock pounder and nonprofit executive. He is commodore of the Connecticut River Drifting Society.

Visit us at
www.historypress.net

This title is also available as an e-book